Leonardo

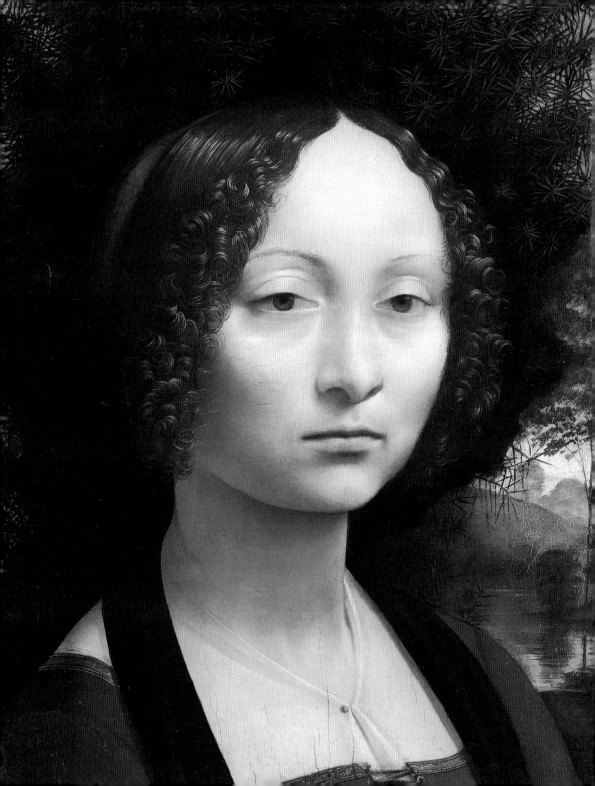

Masters of Art

Leonardo

Milena Magnano

PRESTEL

Munich · London · New York

Front cover: *Mona Lisa (La Gioconda)*, 1503–1505, Louvre, Paris (detail), see page 117
Frontispiece: *Ginevra de' Benci*, c. 1474, National Gallery of Art, Washington (detail), see page 45
Back cover: *Self-Portrait*, c. 1515, Biblioteca Reale, Turin (detail), see page 135

© Prestel Verlag, Munich · London · New York, 2012
© Mondadori Electa SpA, 2007 (Italian edition)

British Library Cataloguing-in Publication Data: a catalogue record for this book is available from the British Library; Deutsche Nationalbibliothek holds a record of this publication in the Deutsche Nationalbibliografie; detailed bibliographical data can be found under: http://dnb.d-nb.de

The Library of Congress Control Number: 2011942811

Prestel Verlag, Munich
A member of Verlagsgruppe Random House GmbH

Prestel Verlag
Neumarkter Strasse 28
81673 Munich
Tel. +49(0)89 4136 0
Fax +49(0)89 4136 2335

www.prestel.de

Prestel Publishing Ltd.
4 Bloomsbury Place
London WC1A 2QA
Tel. +44 (0)20 7323-5004
Fax +44 (0)20 7636-8004

Prestel Publishing
900 Broadway, Suite 603
New York, NY 10003
Tel. +1 (212) 995-2720
Fax +1 (212) 995-2733

www.prestel.com

Prestel books are available worldwide. Please contact your nearest bookseller or one of the above addresses for information concerning your local distributor.

Editorial direction: Claudia Stäuble, assisted by Franziska Stegmann
Translation from Italian: Clare Costa and Ruth Volley
Copyediting: Chris Murray
Production: Astrid Wedemeyer
Typesetting: Andrea Mogwitz, Munich
Cover: Sofarobotnik, Augsburg & Munich
Printing and binding: Mondadori Printing, Verona, Italy

FSC
www.fsc.org
MIX
Paper from
responsible sources
FSC® C018290

ISBN 978-3-7913-4658-8

Contents

Introduction

Leonardo da Vinci was one of the most innovative artists of his time and one of its greatest thinkers; he made advances in civil engineering, invented numerous scientific instruments and machines, and pioneered many fields of scientific research. His extraordinary intellect enabled him to pursue a great variety of very different activities simultaneously. The essential relationship between art, technology, and science—a relationship based on nature and human experience—is reflected in the development of his unique artistic language. Given his total commitment to his research, it is hardly surprising that Leonardo was not a particularly accessible character, and had a reputation for being intimidating. He could well be described as living in a world of his own: his imagination was limitless, and the scope and breadth of his interests, his sublime and unprecedented paintings, the other-worldly beauty of his designs, and even his quirky, left-handed cryptic script, all deepen the impression that this genius inhabited a mysterious world inaccessible to the common man.

A comprehensive study of Leonardo necessitates an exploration of the labyrinth of systems and codes he devised, which were the profuse and sometimes incomprehensible products of a relentlessly active mind. They are contained in the six hundred or so manuscript pages that have survived, which serve as a fascinating record of his mind's ceaseless activity. Yet though encyclopaedic in scope, they contain few observations of a personal kind, for Leonardo gave his undivided attention to nature and the cosmos rather than to himself. Possessing an extraordinary determination and concentration, Leonardo had mental abilities that were the result of the total engagement of all five senses; his was an extraordinary mind eager to learn more about the universe in its every aspect.

However, he was first and foremost an artist, and he viewed life in terms of its emotional and artistic character—and this was true not just of grand occasions but also of the minutiae of daily life. In his intricate portrayal of a blossoming flower or a tiny dewdrop, Leonardo teaches us to see the world through different eyes, and to participate in the life-process he called "the breathing of this terrestrial machine." It is surprising how few of his manuscripts have actually been utilised, given that they contain such a wealth of knowledge in the fields of science and technology. Certainly his texts require a degree of interpretation. But though his writings often remain secret and inaccessible, his thought processes can be seen at work in his paintings. According to Leonardo, painting "begins in the mind of the creator but it cannot come to perfection without manual operation"; and "the science of the painter" makes

him akin to a creator god—"as if possessing the divine mind, such that it can freely summon forth the process of creation."

For Leonardo, this possibility exists for everyone, not just for the solitary genius: he wrote that "it is easy to make oneself universal." His desire was that mankind should push the boundaries of knowledge, should recognize itself as being part of a perfect mechanism supported by a supreme intelligence that created and directs the universe—part of a perfect unfaltering rhythm of continual growth, decay and regeneration based on the laws of nature. Leonardo's legacy encourages us to open our minds to greater things, to seek what his fellow Florentine, the celebrated poet Dante, described as "the love which moves the sun and the other stars."

Leonardo's art is characterized by ambiguity and by his inability to achieve a finished state, both of which might seem indicative of a state of ceaseless flux. The presence of fingers pointing heavenwards in many of his paintings also seems to point to the existence of a greater power sustaining the order behind appearances.

Perhaps the only way to respond to Leonardo's fascinating mind and works is to do as he would have wished: to overstep boundaries, elevate our minds, and look at the world from a higher vantage point. Above all, and avoiding clichés and preconceptions, we need to look attentively and patiently at his paintings in order to discover for ourselves the richness of meaning he was so keen to give them.

Stefano Zuffi

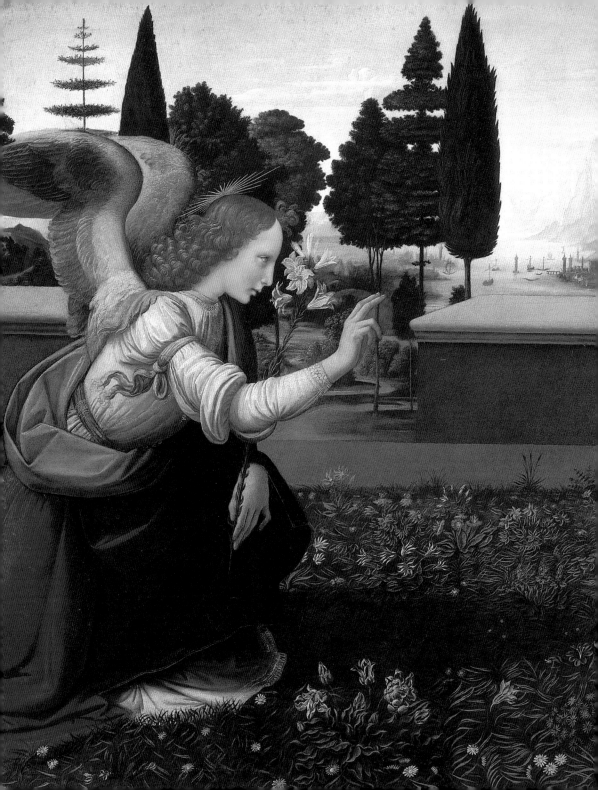

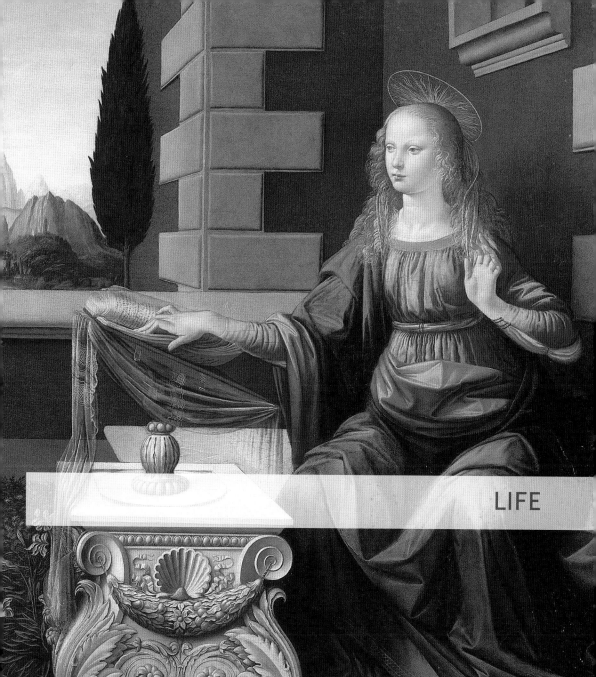

LIFE

The Renaissance *Uomo Universale*

"There was born to me a grandson, the son of Ser Piero my son, on the 15th day of April [1452], a Saturday, at the 3rd hour of the night [10.30 pm]. He bears the name Lionardo [sic]. He was baptized by the parish priest, Piero di Bartolomeo in Vinci." It was Antonio, his paternal grandfather, who recorded the birth of Leonardo da Vinci in his old notary's journal, welcoming the newborn child into the family despite his status as the illegitimate son of the twenty-five-year-old notary Ser Piero and a peasant girl named Caterina, who later married a man called Achattabriga di Piero del Vaccha da Vinci.

Leonardo's childhood

The young Leonardo grew up without a mother, at least until Ser Piero married the affluent Albiera di Giovanni Amadori from Florence, who, being childless herself, brought him up as if he were her own at their home in Anchiano, his native village near to Vinci. However, his cherished stepmother died prematurely on 15 June 1464, and was buried in San Biagio in Florence, where she had presumably moved with Ser Piero. Leonardo's father was an ambitious young notary (lawyer): by 1470 he was already the procurator of the monastery Santissima Annunziata, and soon afterwards he took on the highly prestigious role of notary of the Signoria, the governing council of Florence. Now a public figure, Ser Piero looked after his family well, and a few months after the death of Albiera

he married Francesca di Ser Giuliano Lanfredini, daughter of a highly regarded Florentine notary. In fact, he had two further wives in the course of his life, and a total of twelve children, half of them illegitimate.

In 1469 the young Leonardo moved to Florence, his grandfather Antonio probably having died several years previously. Until then Leonardo had grown up in the countryside close to nature, gaining a familiarity with plants and animals that would stay with him for the rest of his life. The city opened up a completely new life to him.

Leonardo was educated in a piecemeal fashion by Antonio his grandfather, his uncle Francesco, and Piero, the priest who baptized him. Already demonstrating his propensity for creativity, Leonardo taught himself to write with his left hand and in mirror-image.

Ser Piero was aware of his son's rather haphazard approach to learning. As Vasari noted, "he set himself to learn many things only to abandon them almost immediately," and was therefore not capable of following a career in law, as was the family tradition. His father then decided to introduce him to the abacus, but he "confounded his master by continually raising doubts and problems."

It is difficult to determine the precise amount of teaching Leonardo received in those years. Strange as it may seem, it appears that he had difficulty solving basic mathematical problems, was not taught Greek and probably not even Latin, the language of the professional classes;

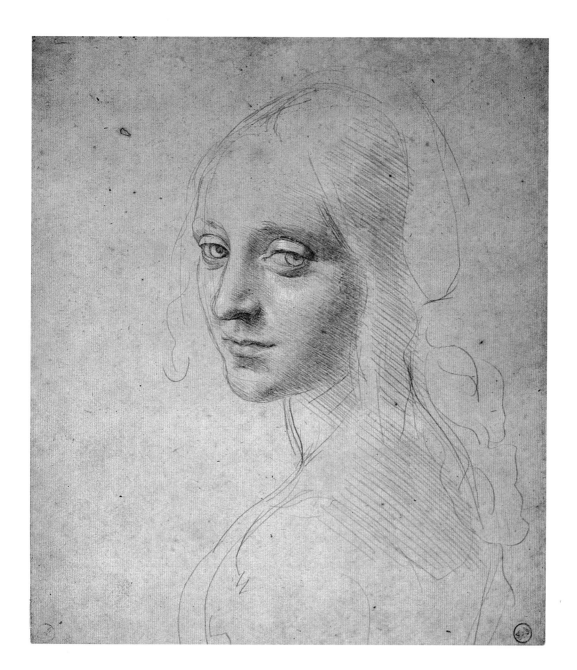

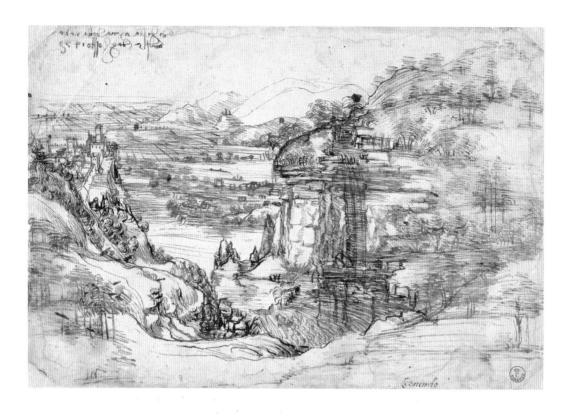

Landscape of the Arno Valley (Landscape with River), 1473, Gabinetto Disegni e Stampe, Uffizi, Florence

by contrast, he was certainly familiar with popular literature in Italian, such as proverbs, fairy tales and folklore, and went on to read the works of Boccaccio, Dante, and Petrarch. This seemingly chaotic education provides an insight into Leonardo's extraordinary mind. He was constantly setting himself challenges, eagerly learning principles from direct experience, and then developing them into original concepts. In later life his mind flitted effortlessly between painting, anatomy, botany, engineering, and hydraulics.

Andrea del Verrocchio's workshop

According to Vasari, when he was seventeen Leonardo was continually "drawing and working in relief," and conscious of this Ser Piero "one day took some of his drawings to Andrea del Verrocchio, who was his close friend, and asked his opinion whether Leonardo would do anything by studying design. Andrea was amazed at Leonardo's early efforts."

So it was decided that young Leonardo should start attending one of the busiest Florentine workshops of the 1470s and 1480s, which belonged to Andrea di Cione, better known as Verrocchio. The studio attracted many of the celebrated figures of the city, including Sandro Botticelli, Domenico Ghirlandaio, Pietro Perugino, and Lorenzo di Credi. Surrounded by such promising young artists, Verrocchio had developed a common artistic language in his workshop, which has made it very difficult to recognize the various hands at work in the numerous masterpieces he created with the help of his young apprentices.

Verrocchio also played a fundamental role in educating the young Leonardo: in his busy workshop Leonardo learned how draw, paint, sculpt marble, and cast bronze; he also had the opportunity to study carpentry, mechanics, engineering, and architecture. Verrocchio's true talent was for sculpting, so it was left to his apprentices to complete the majority of his painting commissions. Sculpture was based on drawing, an important skill for the young apprentice to learn, as Cennino Cennini's *Libro dell'Arte* (*The Craftsman's Handbook*) had pointed out a century earlier. Numerous drawings emerged from Verrocchio's workshop, most notably a series of studies of drapery in which linen cloths are draped over clay models, characteristically executed with fine black lines, heightened with delicate white brushstrokes, that elucidate the three-dimensionality of the forms.

Leonardo's earliest dated work is a drawing of a river landscape, inscribed on the top left-hand corner, in his left-handed script, with the words "On the day of Santa Maria della Neve, 5 August 1473." This depiction of the Arno Valley, with its bushes, rock faces, and fields in the distance creates a unique and innovative atmosphere: it is not merely a sketch or a simple academic exercise, but a faithful representation of a truly authentic and recognizable landscape (one of the very first). The elements of nature were no longer used simply as decorative devices or as a background landscape, but for the first time as the main subject of the scene. It was the product of a sensibility at once artistic and scientific.

A childhood spent growing up in the Anchiano countryside had brought Leonardo closer to nature. His boyhood days spent studying plants or watching the flight of birds had encouraged his desire to gain a deeper understanding of nature and how it works. According to Vasari's accounts, it appears that whilst still a boy Leonardo would go to "the places where they sold birds, take them out of their cages, and paying the price that was asked for them, would let them fly away into the air, restoring to them their lost liberty." Another of Vasari's many anecdotes exemplifies the great analytical ability and the extraordinary sensitivity that set Leonardo apart from others from a very young age: a local peasant asked Leonardo to paint a round shield he had made from a fig tree he had cut down and Leonardo responded with a painting of a "disgusting and terrifying monster which emitted a poisonous breath and turned the air to fire" depicted with such realism that his father Ser Piero, instead of giving it back to the owner, sold it to some art dealers who then sold it on to the Duke of Milan for 300 ducats.

In all of Leonardo's paintings, nature is portrayed with great realism, but this is especially true of his earlier works. Many of the paintings he executed in Verrocchio's workshop can be recognized as such by the accurate description of the landscapes and the elements of nature. An interesting example of this is the

panel depicting Tobias and the Angel (National Gallery, London), attributed to Verrocchio but with the hand of Leonardo discernible in the fish covered in scales, and in the agile little dog. Moreover, many of the landscape backgrounds of the paintings created in the workshop are likely to have been painted by Leonardo because he excelled at them. One example is Leonardo's landscape of rocky peaks in Verrocchio's *Virgin and Child with Two Angels* (National Gallery, London), which has features also seen in Leonardo's *Landscape of the Arno Valley* drawing of 1473.

In 1472 Leonardo entered Florence's prestigious artists' guild, the Compagnia di San Luca. Although by that time he was recognized as an independent artist, and his education considered complete, his close association with Verrocchio continued. In a document dated 9 April 1476, an anonymous denunciation was made to the city officials in Florence that asserted that the seventeen-year-old Jacopo Saltarelli had been accused of engaging in sodomy with four people, including "Leonardo ser Pieri de Vincio," said to stay with Andrea del Verrocchio—*manet cum Andrea del Verrocchio*. The accusation was never acted on.

Pupil and master

The works emerging from Andrea del Verrocchio's workshop during Leonardo's time there were predominantly sculptures, and they were of notable importance during his education

as a young artist; their influence can be seen in particular in the development of his style of decoration using fluid lines and plant motifs, and in his unique ability to depict realistic faces, often with ambiguous smiles.

Although Leonardo's work as a sculptor was not commonly acknowledged, Vasari's observation is interesting: "He fashioned in his youth some laughing feminine heads out of clay, which have been reproduced in plaster, and some heads of children, which were as beautiful as if modeled by the hands of a master." This might suggest that the *Bust of a Lady* (housed in a private collection in Florence), could indeed be the work of Leonardo (as Alessandro Parronchi argued in 1989).

Moreover, several of his sketches and drawings show a striking resemblance to the sculptures created by Verrocchio; for example, his *Profile of an Old Man* (c. 1475, British Museum, London) has a close affinity with the low reliefs of old men that King Mattia Corvino of Hungary commissioned from Verrocchio around this time. Similarly, Leonardo's *Study of a Woman's Hands* (c. 1475, Royal Library, Windsor) is believed to relate to the hands in the missing part of his portrait of Ginevra de' Benci, and also resembles the hands in Verrocchio's sculpture *Lady with Flowers* (c. 1475, Museo Nazionale del Bargello, Florence). Leonardo's influence upon this sculpture is unmistakable.

In many of his earliest artistic creations Leonardo worked with Andrea del Verrocchio,

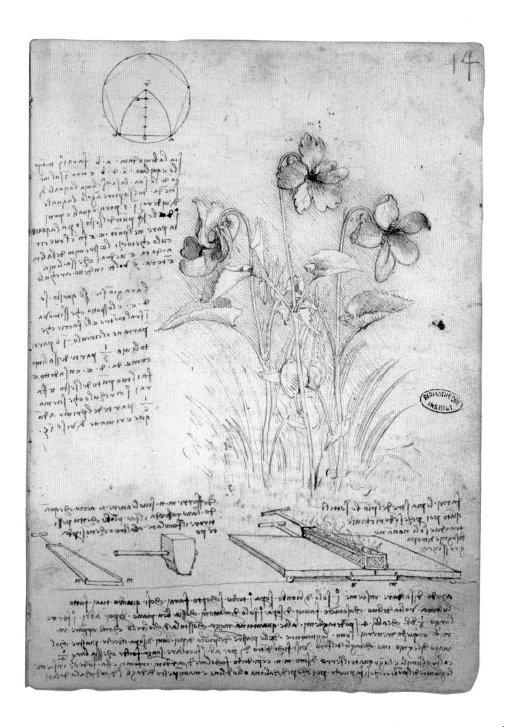

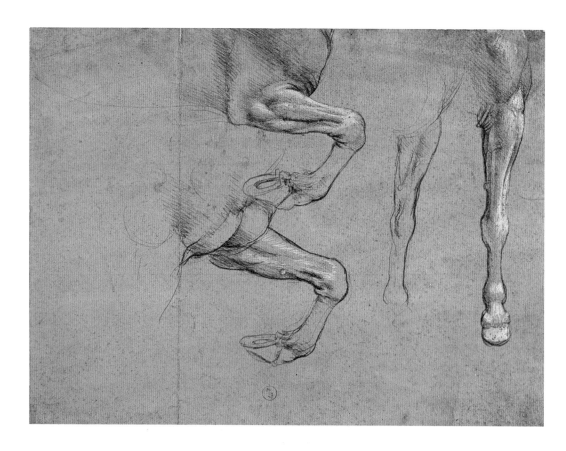

Study of the Forelegs of a Horse, c. 1490, Biblioteca Reale, Turin

but undoubtedly the painting that highlights the direct relationship between master and pupil—who by this time was working alone—is the painting *The Baptism of Christ* in the Uffizi. In his contributions to Verrocchio's painting, Leonardo managed to push the boundaries of what he had learned in his workshop, and to develop an artistic style in which the landscape, human figures, and animals are interpreted with a new, unprecedented naturalism, and in which there is a greater sense of spatial depth and atmosphere.

Discussing this painting, Vasari writes that "Leonardo painted one of the angels, who was portrayed wearing clothes. Although he was still young, Leonardo's angel surpassed that of Andrea's figures to such an extent that Andrea never touched paints again—he was ashamed that a boy understood their use better than he did." In other words Verrocchio was so astounded by the young Leonardo's skills that he stopped painting. In fact, anecdotes showing a gifted pupil overshadowing his master were a common theme in artists' biographies, and this story is unlikely to be literally true. After all, Verrocchio's preference had always been for sculpture, and as the head of a busy workshop he would doubtless have been happy to make full use of the various talents of his pupils.

Leonardo's first works

At the beginning of his independent career, Leonardo's works still bore the unmistakable hallmarks of Verrocchio's style, to a point where several paintings by the young Leonardo were first attributed to Verrocchio himself, or to other apprentices in the workshop. This is the case for the *Madonna and Child with a Pomegranate*, also known as the *Dreyfus Madonna*, a small painting now in Washington, which was once believed to be by Verrocchio or by Lorenzo di Credi, though it exhibits elements intrinsic to Leonardo's style. The painting is renowned for its delicate and almost transparent complexions, and for the tender relationship shown between the Virgin and the Child, elements which are also prominent in the *Madonna of the Carnation* (Alte Pinakothek, Munich), which he painted shortly afterwards.

This closeness in style can be seen not only in these two Madonnas, but also between Verrocchio's *Lady with Flowers* and Leonardo's portrait of Ginevra de' Benci, and even in the ornate decoration of the lectern and lions' paws in the Uffizi *Annunciation*, details of which are reminiscent of Verrocchio's gloomy tomb of Piero and Giovanni de' Medici in San Lorenzo, Florence.

In Leonardo's portrait of Ginevra de' Benci there are also references to the Flemish artistic culture, such as the bright and delicate touches in the hair and the use of color, but in particular in the atmospheric rendering achieved by the delicate touch of the painter's fingertips to smudge the paints, which lends a realistic effect to the woman's complexion. Scientific analysis has found the fingerprints of the young Leonardo on parts of the Uffizi *Annunciation*, for example on the ornamental leaves at the base of the lectern, and on the fingers of the Virgin's right hand. In this painting there seem to be some anomalies of perspective and anatomy evident in the figure of the Virgin, who looks to be too far away from the lectern, so that her right arm appears to have been unnaturally elongated so that she can reach the book; but such features in fact almost disappear when the observer is standing positioned slightly to the right of the painting, which, it is claimed, was the intended viewing point.

What is especially intriguing is that we hear very little about Leonardo's paintings from January 1474 until the fall of 1478, and this at a time when he was at the start of his career, was the product of one of the finest workshops in Florence, and had an influential and supportive father who was trying to secure commissions for him.

It may well be that during this time Leonardo was still uncertain of his own future. Fascinated by science, he started to frequent the geographer Paolo dal Pozzo Toscanelli, whose research influenced the discovery of the Americas. Driven by an insatiable hunger for knowledge, and intrigued by anatomy, he assisted in the dissection of corpses in hos-

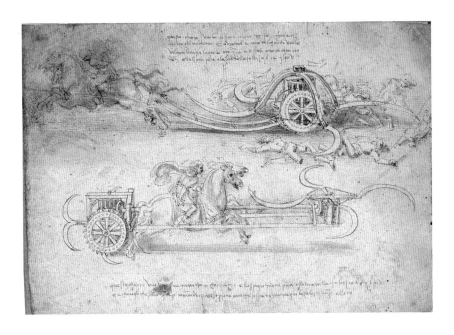

pital mortuaries, and conducted physical and mechanical experiments.

During this period, and up until at least 1480, Ser Piero still looked after Leonardo, who became close to Lorenzo de' Medici, to whom he seems to have offered military and engineering advice, as recorded in some of Leonardo's manuscripts. According to an unidentified author generally known as Anonimo (Anonymous) Gaddiano, Leonardo became part of the Medici circle and was taken under the wing of the sculptor Bertoldo di Giovanni. He started to visit the Medici garden opposite the monastery of San Marco, which was filled with antique sculptures, reliefs, and sarcophaguses that young artists could study. Thanks to his close ties to Lorenzo de' Medici, Leonardo had the opportunity to make a sketch of the hanged corpse of Bernardo di Bandino Baroncelli, one of the chief conspirators in the Pazzi Conspiracy, which had led to the assassination of Giuliano de' Medici on 26 April 1478.

The lure of painting remained strong, however, and there is a partially erased note from Leonardo's diary: "...ber 1478 I began the two Virgin Marys." One of these Madonnas has been identified as the so-called *Benois Madonna* (Hermitage, St. Petersburg). There followed two unfinished paintings: *St. Jerome* (Pinacoteca Vaticana, Vatican City) and *Adoration of the Magi* (Uffizi, Florence). In the first of these, Leonardo's vast knowledge of human anatomy, along with his sure ability to position three-dimensional figures in space, enabled him to paint the saint in such a way that he is more reminiscent of a skeleton than a living man. The second painting is perhaps the most important commission he had obtained to date, thanks to a possible intervention by Ser Piero, who was at the time a notary for the monks of San Donato in Scopeto, who commissioned the work. The task proved difficult right from the outset, for the original contract was particularly complicated. It contained various expectations set out by the monks, for

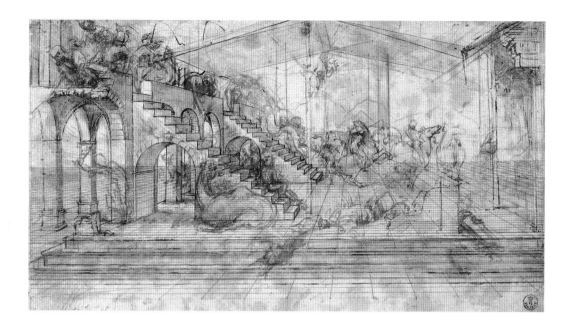

Perspective Study for the Adoration of the Magi, c. 1481, Gabinetto Disegni e Stampe, Uffizi, Florence

example that the work was to be delivered within twenty-four to thirty months at the latest, and that the artist had to provide a detailed account of the cost of materials. The originality of the composition, interspersed as it was with dramatic episodes involving the mysteries of transcendence and death, would certainly not have received a positive response from the monks, who still adhered to a late-medieval Christian iconography. Unfinished, the painting was wisely left in the Benci family home rather than in the monastery.

Life in Milan with "six mouths to feed"

According to Anonimo Gaddiano, when Leonardo was around thirty years old Lorenzo de' Medici sent him to Milan, along with the musician Atalante Migliorotti, to deliver a lyre to Milan's ruler, Ludovico Sforza, known as "il Moro" (the Moor). Vasari describes the lyre as being made by Leonardo himself, in silver, and in the shape of a horse's skull, "a thing bizarre and new in order that the harmony might be of greater volume and more sonorous in tone." It also seems that the artist entered a music competition held in the court of the Sforzas, which apparently he won.

Leonardo spent eighteen of his most fruitful years in Milan, from 1482 to 1499. Florence, the city of scholarship and Neoplatonism, was less suited to an "unlettered man," as he described himself. Milan, however, held a fascination for him because of its openness to new areas of science and technology. In a letter to Ludovico Sforza in 1482, Leonardo spends nine points describing his skills in engineering and defense, and only at the end of the letter does he touch on his actual artistic work—architectural, pictorial, and sculptural—highlighting that these activities could be carried out in times of peace.

It seems that this letter did not initially achieve the result the artist had hoped for. He did not receive his first commission until 25 April 1483, and it came from the Confraternity of the Immaculate Conception of the

Virgin (Concezione di Maria). It was a commission to paint a polyptych for the chapel in the church of San Francesco Grande in Milan, together with the brothers Evangelista and Ambrogio de Predis; it was to be completed before the 18 December the same year. The contract was very detailed, and had to be signed by all the artists. The decoration was to be rich, with generous amounts of gold leaf; the central altarpiece had to depict the Madonna among angels and with two prophets, whilst the side panels were to show four angels playing musical instruments and singing. However, for the central panel of the polyptych Leonardo painted what has become known as *The Virgin of the Rocks* (Louvre, Paris). With typical ingenuity he interpreted the iconographic requirements of the commission in his own way, namely an imaginary encounter between the infant Christ and the infant John the Baptist in the wilderness, which was a common theme in Florentine art. This painting seems not to refer explicitly to the mystery of the Immaculate Conception; rather, the arid geological scenery creates an atmosphere of dusky intimacy that reveals the mystery of nature and man's relationship to it. The figure of the Virgin seems to merge into the rocky ravine, intensifying the sense of mystery associated with motherhood. Warm light floods the natural landscape, and the prophetic gestures of the figures herald the inevitability of the Passion.

During this time, when Leonardo probably lived in the house of the De Predis brothers, he continued with his technological inventions and mechanical studies alongside his designs for military machines. Once firmly ensconced in Ludovico's circle, Leonardo was keen to demonstrate his versatility: his activities ranged from landscape irrigation projects to portraits, from set designs for court festivals to a grandiose equestrian statue of Francesco Sforza.

But life in Milan also had its problems. In a letter to Ludovico Sforza, Leonardo complains of having received only fifty ducats in three years, too little with "six mouths to feed," referring to himself, his three students— Marco d'Oggiono, Giovanni Boltraffio, and Gian Giacomo Caprotti, better known as Salaì—a servant, and, after 1493, a woman known as Caterina the Maid, whom some have identified as Leonardo's mother, who probably came to Milan after becoming a widow.

Leonardo as court painter

By the time *The Virgin of the Rocks* was finished, Leonardo would have been working on other paintings, with the assistance of his students. It seems highly likely that he was *l'optimo pictore* ("the best painter") referred to by the King of Hungary, Matthias Corvinus—the artist who had painted "a figure of Our Lady as beautiful, as superb, and as devout as he knows how to make without sparing any effort." This refers to a painting given to the king, and is documented in a ducal letter dated

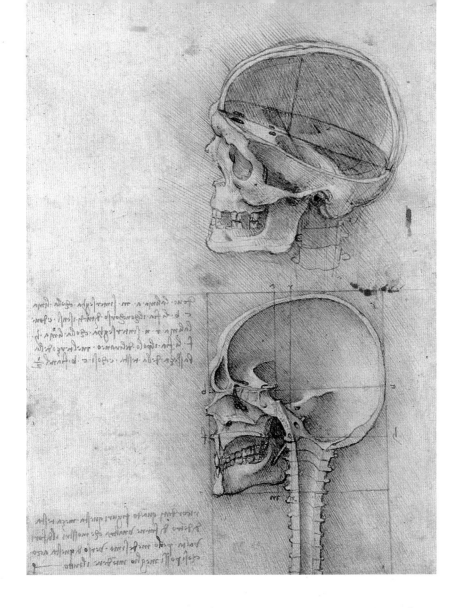

Cross-Section of a Skull, c. 1489, Royal Library, Windsor

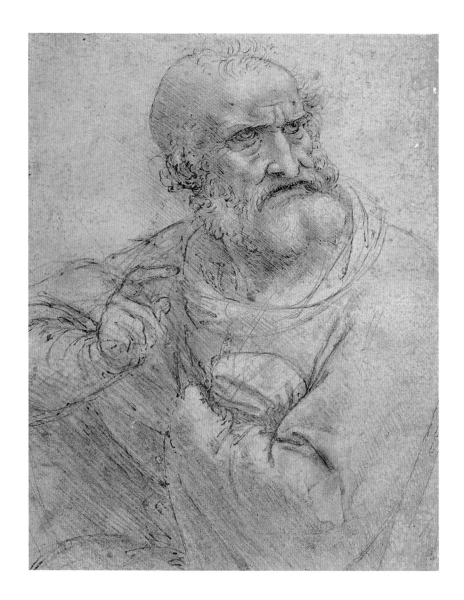

*Study of the Figure of
St. Peter for the Last
Supper, c. 1488–1490,
Albertina, Vienna*

13 April 1485. Moreover, during this period of collaboration with his pupils he probably created the painting known as the *Madonna Litta* (Hermitage, St. Petersburg), though it is usually attributed to Boltraffio or Marco d'Oggiono. Among his Milanese works there are several portraits, and it is significant that Leonardo resumed his study of the human body that he had begun in Florence, showing a keen interest in the relationship between the physiognomy of a man and the psychological and moral aspects of his character, which he called *moti dell'animo*, the "movements of the soul." Leonardo believed that every external characteristic of an individual was in essence the expression of a psychological or moral trait. The subject of *The Musician* (Pinacoteca Ambrosiana, Milan) is most likely the writer of musical treaties Franchino Gaffurio, who was the choirmaster at the cathedral in Milan, and whom Leonardo depicted as a man capable of great analytical thought and contemplative focus. Likewise, in his *Portrait of a Woman*, also known as the *La Belle Ferronière* (Louvre, Paris), the observer is held by the intense yet evasive gaze of the woman. Towards the end of the 1490s Leonardo was given his first genuine commission by the Duke: a portrait of his young lover, Cecilia Gallerani. After having completed a wonderful drawing, Leonardo painted what is known as the *Lady with an Ermine* (Czartoryski Museum, Cracow), in which the presence of the animal, which in Greek transliterates as *galé* (mean-

ing an ermine), apart from alluding to the family name of the young lady, refers to the accolade bestowed upon Ludovico Sforza, the Order of the Ermine, which had been created by Ferdinand of Aragon in 1465.

Commissions from the Duke were now becoming more frequent: Leonardo records that Marquis Stanga, superintendent of finances at the Sforza court, asked him to design the decorative scheme for the marriage celebrations of Gian Galeazzo Sforza and Isabella of Aragon (postponed until the following year following the unexpected death of the mother of the bride, Ippolita Maria Sforza), and he was paid in advance for the expenses he would incur in making the model for the famous equestrian monument of Francesco Sforza. This was an epic undertaking, not only because of the huge dimensions of the statue, but also because Leonardo wanted to create a rearing horse, a horse in the midst of combat. This meant that he spent month after month in stables observing the anatomy of the animals, studying and recording the muscles and tendons relaxing or tensing, and every small detail of the body. But too much time elapsed, and Leonardo, unable to finish his work, was forced to abandon it for some time so that he could devote himself to the nuptial celebrations of Isabella and Gian Galeazzo, whose wedding became known as the "Feast of Paradise." After numerous mishaps, it finally went ahead on 13 January 1490. The "sky" created by Leonardo, and the

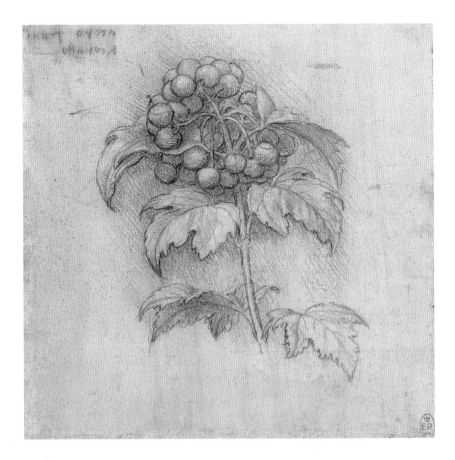

Marsh Blueberry, c. 1506, Windsor, Royal Library

pleted in 1495. The other scene was instead entrusted to Leonardo, an important commission that resolved his financial worries and proved to be the culmination of all his studies over the years. The subject, which was widely known in the figurative tradition of fifteenth-century Florence, was interpreted in a unique manner. Leonardo finally chose the dramatic moment when Christ says: "Truly, truly, I say to you, that one of you shall betray me." These words cause visible consternation (expressing Leonardo's concept of *moti dell'animo*, the "movements of the soul") among the apostles, who are portrayed in four groups of three, with the isolated figure of the Redeemer dominat-

ing the center. Leonardo did not like the technique of fresco, which dries quickly, so used a mixture of tempera and oil applied to two coats of plaster, a method that was advantageous for Leonardo not only because it allowed far more time to complete the final detailed phases of the work, but also because it made possible a more subtle rendering of light. But unfortunately this technique was not well-suited to the humidity of the refectory in Santa Maria delle Grazie, and as early as 1517 Antonio de Beatis noted that the colors had already started to fade. The famous Milanese masterpiece had to be finished in 1498, when it was commemorated in the *De Divina Pro-*

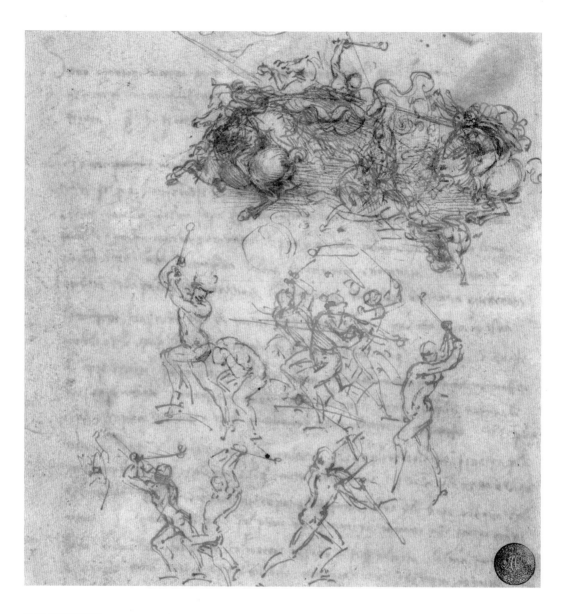

*Study of Proportions
for the Battle of
Anghiari: Infantrymen
and Cavalrymen,
1503–1504, Gallerie
dell'Accademia, Venice*

Robertet, Secretary of State to the King of France, depicting the Virgin as if she were about to spin yarn, whilst the Child holds the yarn winder, which was formed in the shape of a cross. This is a reference to the *Madonna of the Yarn Winder*, of which there are several versions; of the two most likely to be by Leonardo, one belongs to a private collection in New York; the other, stolen from the Duke of Buccleuch's art collection some years ago but then recovered, is now in the National Gallery of Scotland in Edinburgh.

By this stage Leonardo was working full time as a painter, but the following year he also took on the role of military architect and engineer for Cesare Borgia, who had been in Milan since the end of 1499. The son of Pope Alexander VI, Cesare proved to be one of the most ferocious tyrants of the era, but for him Leonardo invented a new type of gunpowder made up of a mixture of sulfur, charcoal, and saltpeter, he designed flying machines and submarine war instruments, inspected bastions and strongholds, and drew up detailed maps to facilitate the strategic and military plans of the Borgias. It was alongside Cesare Borgia that Leonardo witnessed one of the most brutal experiences of his life: the conquest of Urbino. It was in Urbino that Leonardo and Niccolò Machiavelli became friends, though they probably first met in Florence.

Leonardo escaped the collapse of the Borgias just in time, and in the spring of 1503 the Florentine Republic entrusted him with an engineering project that entailed diverting the course of the River Arno away from the city of Pisa. However, the dam failed due to an error in calculation, much to the anger of Piero Soderini, who had also entrusted Leonardo with the execution of a large fresco in the Sala del Maggior Consiglio (Hall of the Great Council) in the Palazzo della Signoria, which was also left unfinished. The decoration of the Salone dei Cinquecento (Hall of the Five Hundred) put the two most sought-after artists at the time in direct competition: Leonardo and Michelangelo. Leonardo was to paint an episode from the conflict between the Florentine and the Milanese armies, the Battle of Anghiari, which had been fought on 29 June 1440, whilst Michelangelo was commissioned to paint the Battle of Cascina, which took place on 29 July 1364 with a Florentine victory over Pisa. In fact, neither of the two scenes was completed: Michelangelo was summoned to Rome by Pope Julius II, and Leonardo finished only a part of the mural painting and his cartoon was later lost. However, Peter Paul Rubens was still able to copy the central scene around the banner in a painting (Louvre, Paris). Around the same time, Leonardo had been preparing the cartoons for a painting in Santa Maria Novella. As usual, he was experimenting with a new technique known as encaustic (wax), but the results were disastrous: the paint failed to dry properly, it stuck to the plaster, and tended to fade, sometimes disappearing altogether. By the December of

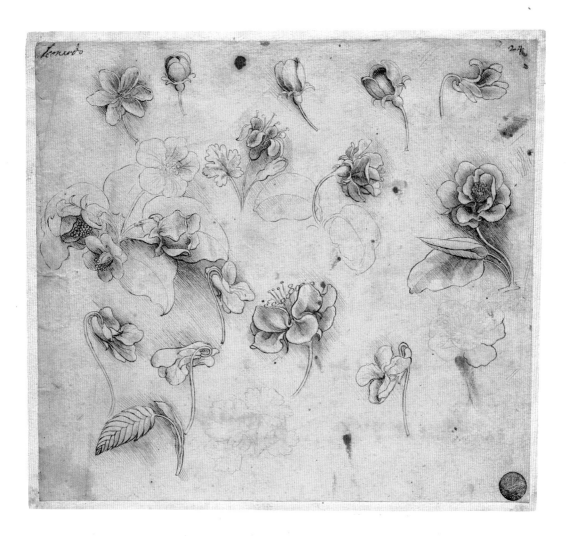

1503, the artist was left totally dispirited by this, and he stopped transferring his painting of the battle from the cartoon to the wall. His enthusiasm for invention also had a detrimental effect on the *Last Supper* in Milan. Affected by the humidity, it started to lose paint only a few years after it was completed, and the color was at risk of fading completely.

Despite the frustrations of his recent failures, Leonardo now embarked on his unfor-gettable masterpiece, the *Mona Lisa*. He began the portrait in Florence and carried it with him on his travels to France. The identity of the lady featured in the painting is traditionally recognized as Mona Lisa, wife of the Florentine merchant Francesco del Giocondo, but it remains unclear as to why Leonardo kept the painting, and why it was never delivered to the client. The art critic Charles de Tolnay, writing in 1951, maintained that the *Mona*

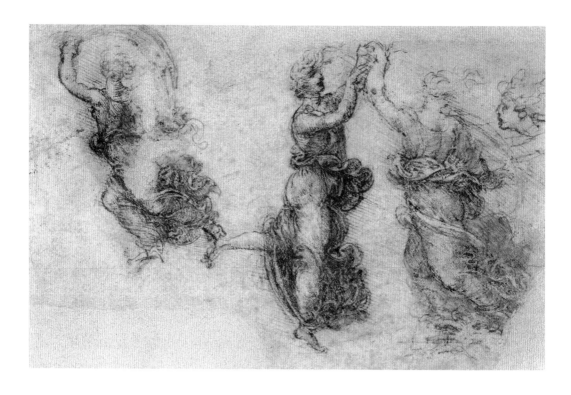

Lisa was not just a portrait belonging to a particular social class and era, but a representation of a universal value—that Leonardo was expressing himself as a poet and philosopher as well as a painter. As a formal portrait, the composition was highly influential in the development of Florentine portraiture, but more importantly the enigmatic expression seems to be stating the philosophical truth that the spirit may be present even though ultimately inaccessible.

France: in the service of Francis I

During his stay in Florence, Leonardo received many compliments from the French governor of Milan, Charles d'Amboise, who by 1506 had urged him into the service of King Louis XII of France. The following year, the governor asked the Signoria of Florence whether Leonardo might return to Milan for a while, which he did from July 1508 to September 1513. Leonardo's second stay in Milan was very productive: he painted the *Virgin and Christ with St. Anne* (Louvre, Paris); completed the second version of *The Virgin of the Rocks* (National Gallery, London), most likely painted with Ambrogio de Predis; and also began working on geological and maritime issues, town planning, and sculpture. He designed an equestrian statue to celebrate the leader Gian Giacomo Trivulzio, who led the French forces in the invasion of Milan, though this too was never completed. In the meantime, Leonardo continued to travel: he visited Como, climbed Monte Rosa, and in Vaprio d'Adda was entrusted with the young Giovan Francesco Melzi by the boy's father. He was Leonardo's last and dearest pupil, who was with him until his death.

In 1511 Leonardo's ardent supporter Charles d'Amboise died; two years later a new war led by the League of the Cambrai forced the French to leave Milan, and the Sforza family once again ruled the city. Leonardo then decided to leave, and on 24 September 1513 headed to Rome with his two most devoted students, Melzi and Salaì. In Rome, Julius II had died, and Pope Leo X (a Medici) had acceded to the papal throne. Giovanni de' Medici was now in power, and he and his brother Giuliano bestowed their favor on Leonardo. Giuliano ensured that Leonardo had lodgings in the Belvedere Palace, where he could concentrate on his scientific and anatomical studies, and on his scheme for the draining of the Pontine Marshes. Following Giuliano de' Medici and Pope Leo, Leonardo traveled to Bologna, where he met the King of France, Francis I, who was to be his last patron. His sojourn in Rome had not been as fruitful as he had hoped, due to misunderstandings with Leo X and then the death of Giuliano in 1516. For this reason, Leonardo decided to accept the invitation from Francis I to go to France. Cultured, sophisticated, and an art lover, the French king invited Leonardo to stay in the Château du Clos Lucé in Amboise, in the magnificent countryside of the Loire Valley. His three-year stay in France, in the company of Salaì and the young Melzi, was undoubtedly the most peaceful period in his life. Leonardo was becoming weaker with age, and most likely suffered a cerebral thrombosis that left him partially paralyzed in the right hand, but this did not keep him from his studies and scientific research. He died in France on 2 May 1519 at the age of seventy-seven, having signed his will on 23 April: the majority of his drawings and manuscripts were to go straight to his faithful student Giovan Francesco Melzi, some paintings to Salaì, four hundred *scudi* was to be donated to Santa Maria Nuova, and a farm in Fiesole was to be given to his stepbrothers. He had even planned his own funeral carefully; he was to be buried in the church of Saint Florentin in Amboise. His remains were scattered during the French Wars of Religion (1562–1598).

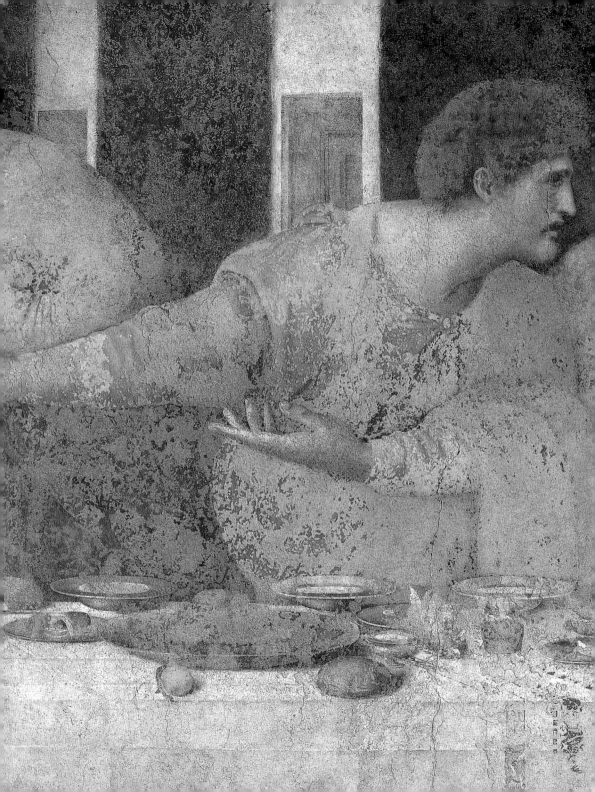

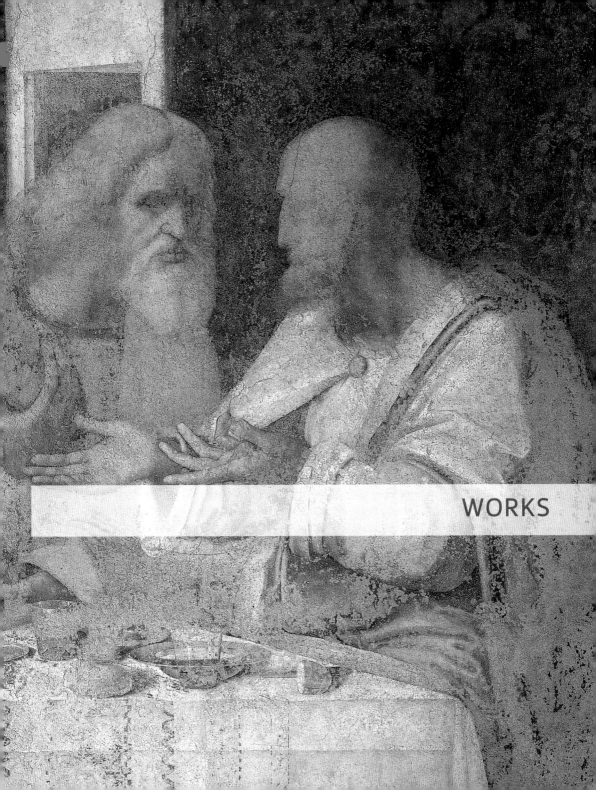

WORKS

Madonna and Child with a Pomegranate (Dreyfus Madonna)

c. 1469

Oil on wood, 15.7 x 12.8 cm
Kress Collection, National Gallery of Art, Washington

This small painting was once attributed to the workshop of Verrocchio, sometimes more specifically to Lorenzo di Credi; but more recent studies have argued that this is one of the earliest extant works of Leonardo. There are many stylistic analogies with the early works of the young Tuscan painter, such as the tender relationship between the Virgin and Child, which resembles that seen in the *Madonna of the Carnation* (Alte Pinakothek, Munich), the pose of the Virgin's left hand as it offers the pomegranate, and the plump, uplifted arm of the Child; similarly, the young Virgin's hair is very like that portrayed in the Uffizi *Annunciation*. The two figures in the foreground emerge from the obscurity of a room, and are bathed in a soft light that falls from above, revealing a delicate chromaticism. The Virgin stands behind a parapet, supporting the Child as he takes a few faltering steps, his feet protected from the cold stone with her blue cloak. The figure of the Child is projected into the foreground, his gaze raised heavenwards, and through the windows there are glimpses of a landscape as yet relatively undistinguished. The critics Wilhelm Suida and Bernard Degenhart were the first to suggest that this work, like the *Madonna of the Carnation* (Alte Pinakothek, Munich) and the *Benois Madonna* (Hermitage, St. Petersburg), bears the hallmarks of Leonardo's characteristic blurring of colors and tones (*sfumato*). The delicacy of the painting, the precision of the brush-strokes, and the juxtaposition of blue, red, yellow, and green are further hallmarks of Leonardo style.

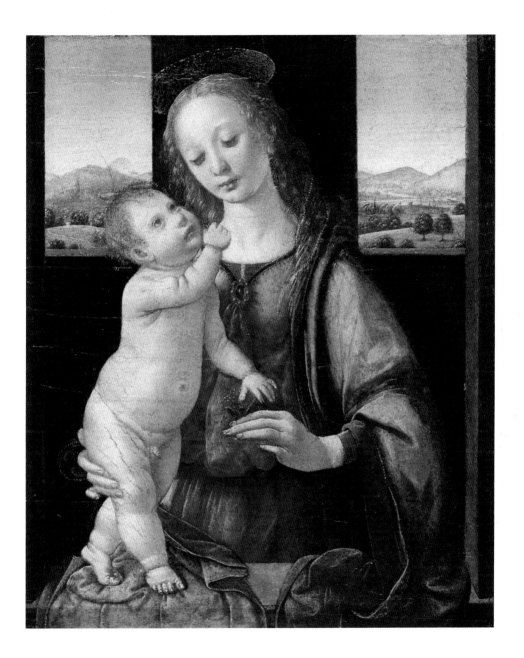

The Annunciation

c. 1472–1475

Oil on wood, 98 x 217 cm
Galleria degli Uffizi, Florence

This work comes from the church and convent of San Bartolomeo di Monteoliveti, near Florence. It was traditionally attributed to Domenico Ghirlandaio, until studies conducted around the time of its transfer to the Uffizi in 1867 suggested that it may be an early work by Leonardo. There are evident similarities to the works produced by those close to Verrocchio, notably the graceful gestures of the figures and the abundant folds of drapery. The lectern and the stone table, especially the lion's-paw feet and the plant decoration, closely resemble features found in the funeral monument to Giovanni and Piero de' Medici in the Old Sacristy in San Lorenzo in Florence, a monument completed by Verrocchio. The Virgin is seated outside a typical Florentine Renaissance villa, her left hand raised in a delicate gesture of acceptance of the divine message, whilst her right touches the pages of the holy book. However, the effect of the gesture is hampered by the excessive distance between her and the lectern, which makes the figure of the Virgin appear too far away to be realistic, the right arm excessively long. This apparent deformation in perspective diminishes, however, when the observer is standing in the intended viewing point, slightly to the right of the painting. The wings of the archangel, the carpet of flowers, the imaginary northern landscape in the background, with its boats, pointed towers and rocky mountains, and the softly pervading light of dawn gently illuminating the figures—all are elements that in their almost scientific detail foreshadow the successive stages in the evolution of Leonardo's style.

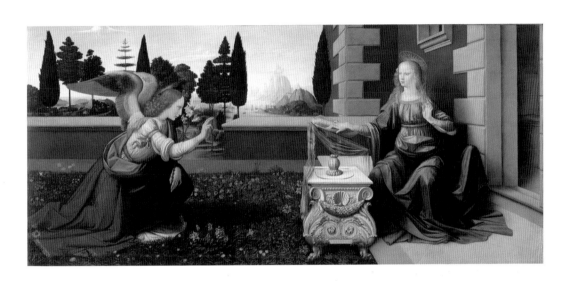

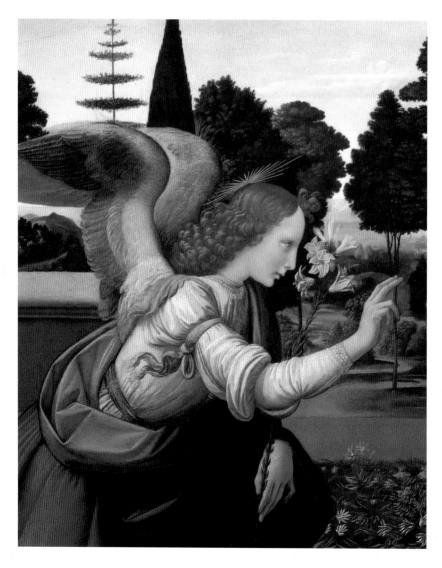

The Annunciation
(details)

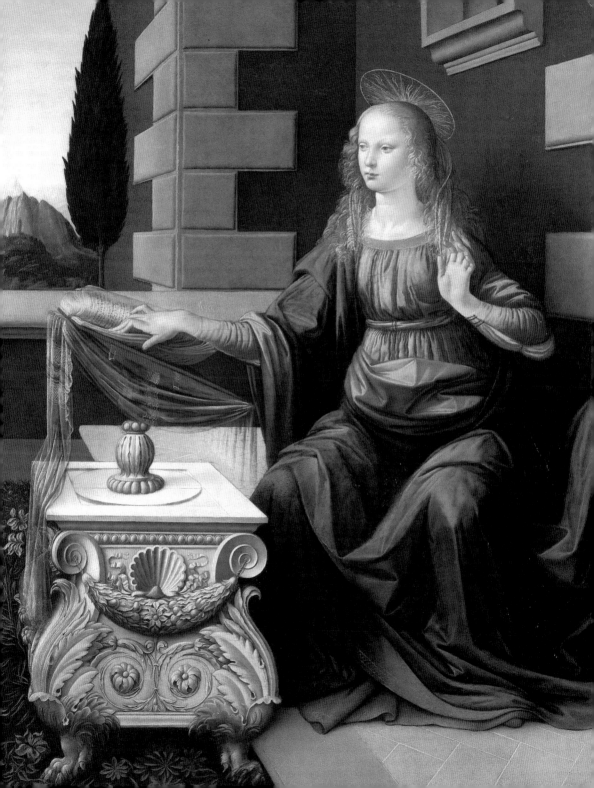

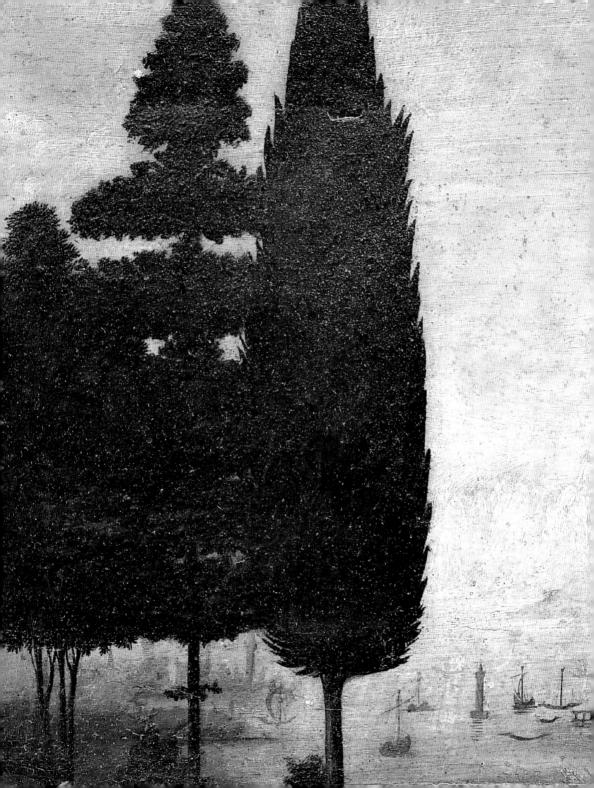

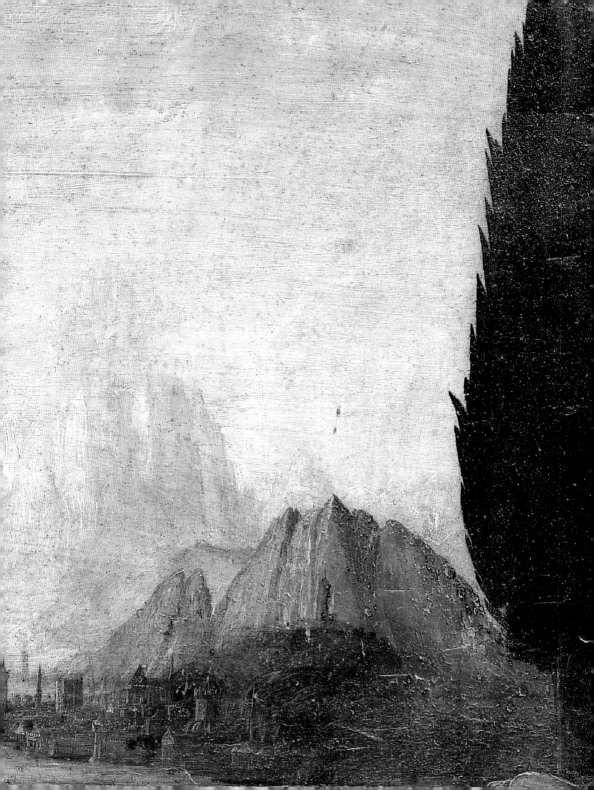

Madonna of the Carnation

c. 1473

Oil on wood, 62 x 47.5 cm
Alte Pinakothek, Munich

Some critics have identified this work as the "Madonna of the Vase" mentioned by Vasari: "Leonardo has done an excellent painting of Our Lady for Pope Clement VII. Amongst other things he accomplished, there is a vase full of water with a few flowers in it, which is not only wonderfully lifelike, but echoes the dewdrops in the background in such a way as to look more realistic than the real thing!"

It marked an important step in Leonardo's artistic development, both in terms of form and composition. Two sets of mullioned windows frame the landscape, which is articulated through successive planes, and the light falls on the figures of the Madonna and Child from the front, rendering them more monumental, though without any hint of rigidity; indeed the fluidity is maintained by gestures such as the Virgin's right hand gently resting on the young Savior's back. The painting is one of Leonardo's early works, and there are some similarities with the style of Verrocchio's workshop, but there are also some individual characteristics that resemble those found, for example, in the Uffizi *Annunciation*. Prefiguring elements of Leonardo's mature style, these characteristics include the rocky landscape in the background, visible through the windows, the yellow folds of drapery knotted into a spiral, which are reminiscent of his later studies on hydraulics, and the plaited hair of the Virgin, which is similar to that shown in his preparatory sketches for the figure of Leda.

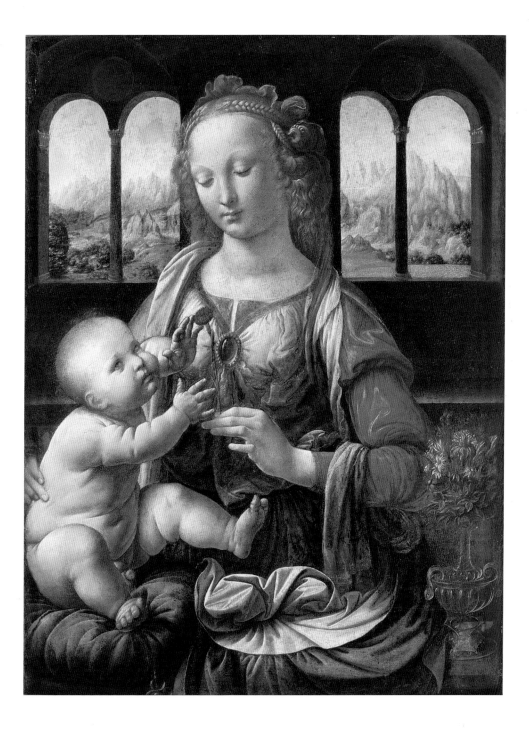

Ginevra de' Benci

c. 1474

Oil and tempera on wood, 38.8 x 36.7 cm
National Gallery of Art, Washington

The front of this panel shows the portrait of a young woman identified as Ginevra de' Benci, daughter of the Florentine banker Amerigo di Giovanni Benci; in 1474, at the age of seventeen, she was married to Luigi di Bernardo di Lapo Nicolini. The painting is rich in allusions: the fronds of juniper behind Ginevra's shoulders help to identify her (*ginevra* means juniper in Italian), as does the painting on the reverse, which depicts a sprig of juniper surrounded by a garland consisting of a branch of bay tree and a branch of palm, with the inscription "Virtutem forma decorat" (Beauty Adorns Virtue).

The portrait shows a young woman with strong, stern features, against a landscape full of abundant vegetation and water. There are clear references to Flemish art, such as the decorative touches to the hairstyle, the particular attention to detail, and the delicate luminosity of the skin, which suggest that Leonardo may have been influenced by Jan van Eyck, incorporating various elements of the Flemish artist's style in his own work. It seems likely that a third of the painting was cut off at the bottom, and that it would originally have shown her hands, though perhaps only sketched in. Sketch No. 12558 at Windsor Castle may have been a study for those hands. They are very similar to those of the portrait bust known as the *Lady with Flowers* (c. 1475, Museo Nazionale del Bargello, Florence), which was sculpted by Verrocchio; careful critical observation has given much credence to the hypothesis that this sculpture was executed by Verrocchio with the help of Leonardo.

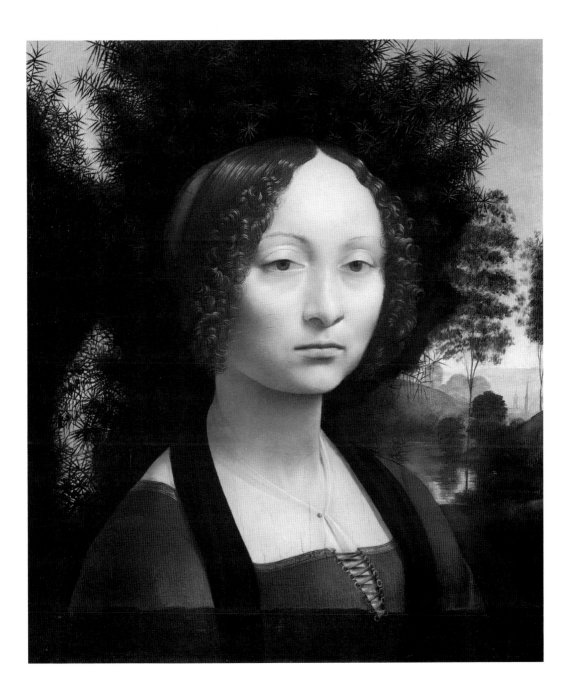

The Baptism of Christ

1475–1478

Oil and tempera on wood, 177 x 150 cm
Galleria degli Uffizi, Florence

According to Vasari, "Whilst Andrea del Verrocchio was working on a painting of St. John the Baptist baptizing Christ, Leonardo painted one of the angels, who was portrayed wearing clothes. Although he was still young, Leonardo's angel surpassed that of Andrea to such an extent that Andrea never touched paints again—he was ashamed that a boy understood their use better than he did."

Vasari's well-known anecdote of the pupil outshining his master suggests a relatively early date for the painting. However, X-ray examinations have shown that in the case of the angel in profile, Christ's hair, and certain parts of the landscape in the background on the left, the tempera underpainting was covered with an oil glaze, which suggests Leonardo's involvement. The quality of Leonardo's contribution shows a technical maturity that would suggest a date later than that of the portrait of Ginevra de' Benci in the Uffizi. More recent studies have confirmed the hand of Leonardo at work in other areas of the painting, namely in the river, whose waters flow over the feet of Christ and St. John the Baptist, and in areas of Christ's face and body. The rendering of the muscles and an evident anatomical accuracy are particularly clear in the figure of the Baptist. These characteristics of Leonardo's style prefigure the St. Jerome in the Pinacoteca Vaticana and all of his other mature works.

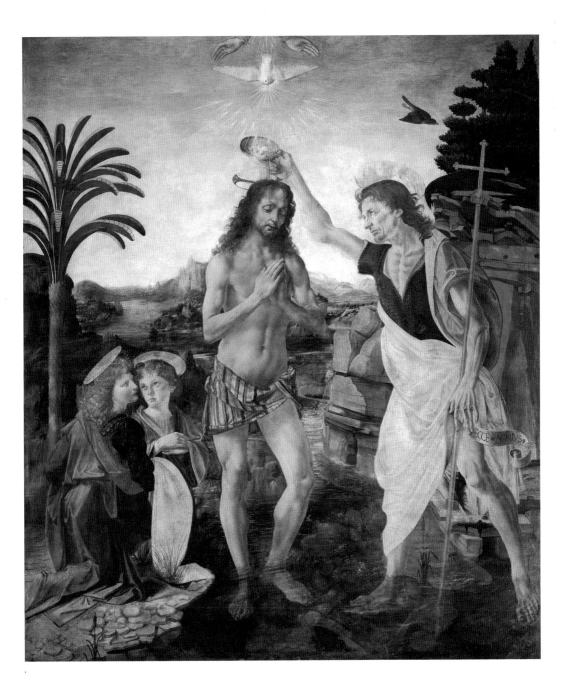

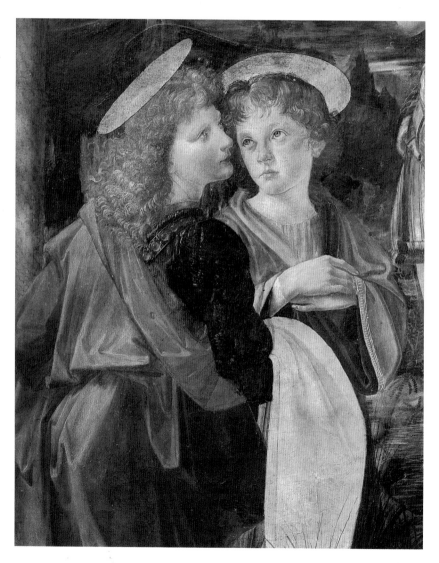

The Baptism of Christ
(details)

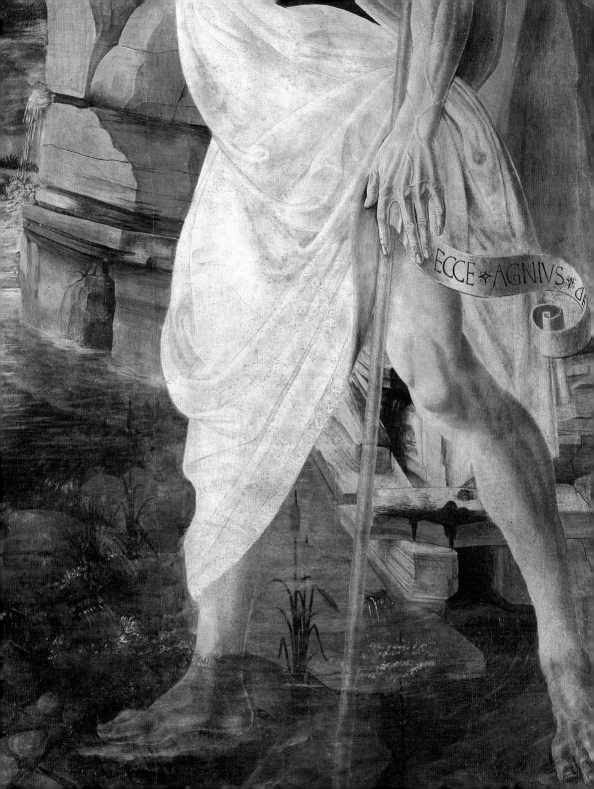

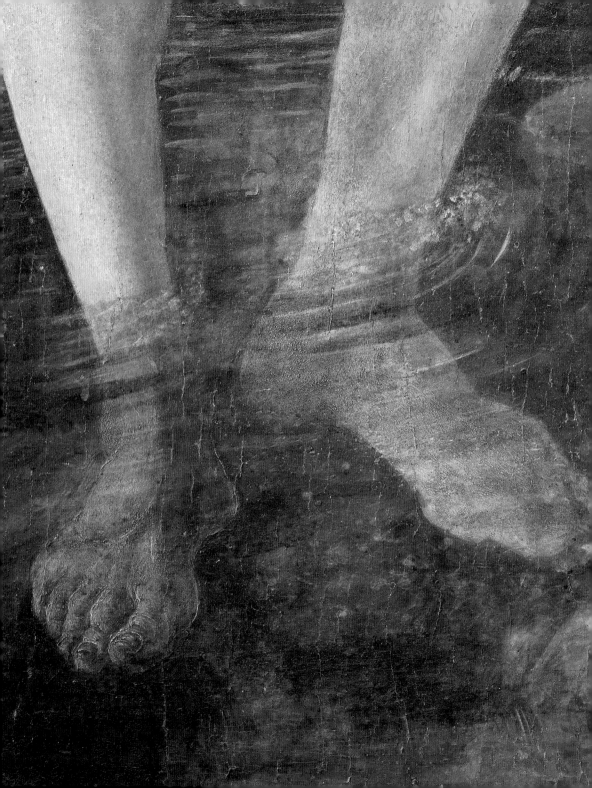

The Annunciation

1478–1480

Tempera on wood, 16 x 60 cm
Louvre, Paris

When this painting was obtained by the Louvre in 1863, it was ascribed to Lorenzo di Credi. Subsequently, it was identified as part of the predella of the altarpiece known as the *Madonna della Piazza* in Pistoia cathedral, a work commissioned from Verrocchio but executed by his pupils: Lorenzo di Credi painted the central section and the scene on the predella, *St. Donatus of Arezzo and the Tax Collector* (Worcester Art Museum), Perugino the *Birth of St. John the Baptist* (Liverpool Art Gallery), and Leonardo the *Annunciation*. The attribution to Leonardo still causes some concern, particularly with regard to the way in which the panel was executed, and the use of color. It is generally agreed that he was involved only in the final stages of painting, when Verrocchio's design had already been executed. "The hand of Leonardo can be identified in this small panel, described by [Jack] Wasserman as 'at best a mediocre work of art' (1982), by the existence of a drawing by Leonardo in the Uffizi. The drawing shows the profile of a female head bending downwards in the manner of the Virgin on the Louvre panel. The discrepancy in quality between this autograph sketch and the inferior painting is most likely due to the necessity of condensing the drawing in all its dimensions and details. The sketch was most likely of a real-life model assuming the elegant, aristocratic pose typical of the style of Verrocchio and his workshop at that time" (Pietro C. Marani, 1989).

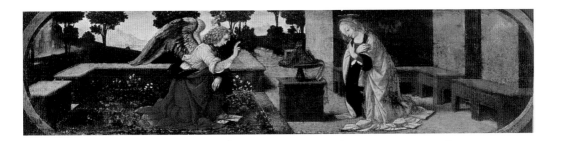

Madonna and Child (Benois Madonna)

1478–1482

Oil on wood, transferred to canvas, 48 x 31 cm
Hermitage, St. Petersburg

This painting takes its name from the family who owned it for many years. There is no doubt as to the authorship of this painting, and scholars are agreed that it is one of the most complete and therefore valuable testimonies of Leonardo's transition in style at the pivotal point in his career when he moved from Florence to Milan. Most unusually, this youthful Virgin breaks into a smile at her child's tentative attempts to coordinate his movements and focus his gaze. Leonardo was one of the first painters to set himself free from a rigid adherence to conventional composition formulas. The figure of the baby Jesus was clearly modeled on real-life observations of children only a few months old, and Leonardo reproduces the proportions and shapes in a realistic manner, even capturing the ungainliness that makes the Madonna smile.

It is this painting in particular that highlights how far Leonardo's path diverges from that of the other Florentine painters of his generation such as Botticelli, Ghirlandaio, and Perugino. For them, a painting was an exercise in mastery: the aim was to show as much technical ability as possible, and therein lay the value of the painting. For Leonardo, painting was about discovering and interpreting the natural world. The clear, graphic language of the Florentine painters was skilful but unnatural, whereas the delicate *sfumato* (blurred, smoky) effect of Leonardo's pictorial language could better represent the state of cosmic flux that he saw as pervading the whole of nature. The eternally changing universe was evident not only in cataclysmic events, but in the small moments of everyday life, such as a baby trying to grasp an object, responding to the smile of his mother.

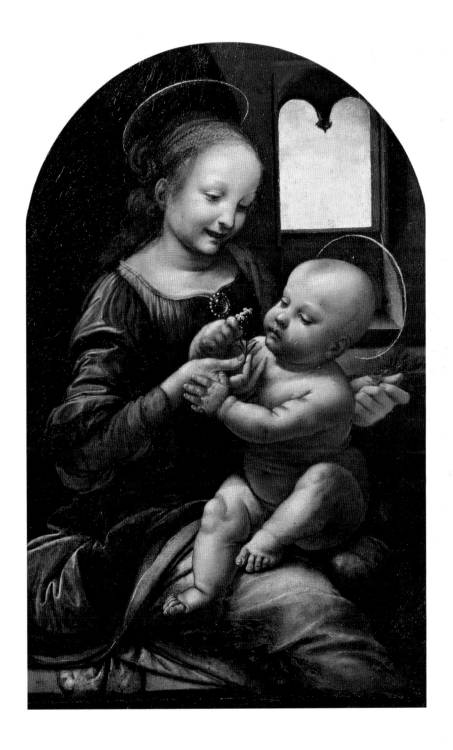

Madonna and Child
(Benois Madonna)
(details)

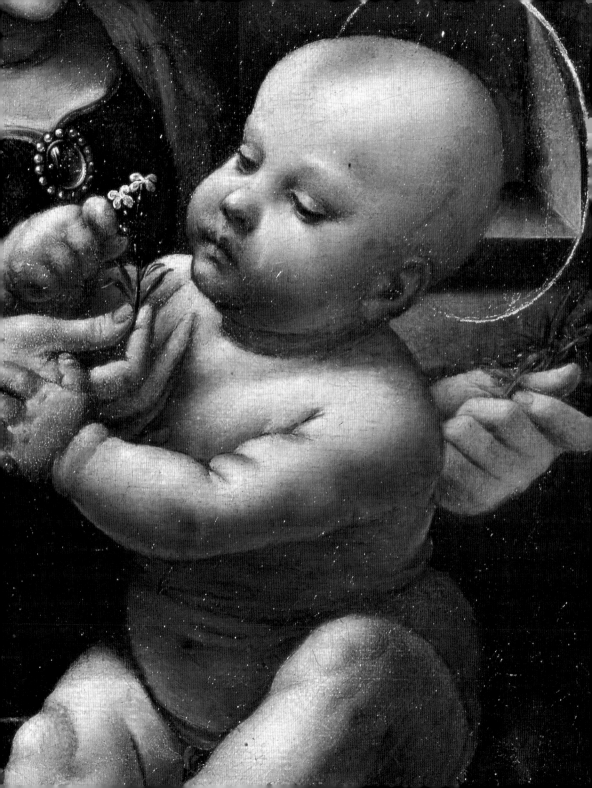

St. Jerome

c. 1480

Oil on wood, 103 x 75 cm
Pinacoteca Vaticana, Rome

Although Leonardo makes reference to a St. Jerome in the list of works he completed prior to his departure for Milan, it is not certain that the artist was referring to this painting, though its closeness in style to the *Adoration of the Magi* in the Uffizi would seem to confirm that it was indeed completed during the last phase of his first Florentine period. The painting shows the penitent St. Jerome with his right arm stretched out into space, his left hand close to his heart, and his reflective gaze turned towards heaven. The physiological rendering of his sunken features, which echoes references in classical texts by the Roman writer Seneca, and the anatomical accuracy of the neck, torso, and leg, in which every tendon, bone and muscle is discernible and realistic, constitutes a striking testimony to the maturity of Leonardo's skills both as an artist and as an acute observer.

Despite the complete absence of any documentation, since its discovery no one has disputed the authorship of the painting. One scholar has suggested the slightly implausible hypothesis that the painting once belonged to the eighteenth-century Swiss painter Angelica Kaufmann, and was then lost and cut in two. Supposedly, Cardinal Fesch then found the lower part in a junk shop in Rome, where it had been turned into the lid of a chest, and years later found the other half, which was being used as a table by his cobbler. What is certain is that Pope Pius IX bought the painting from the cardinal's heirs for 2,500 francs and housed it in the Vatican Museum, where it remains.

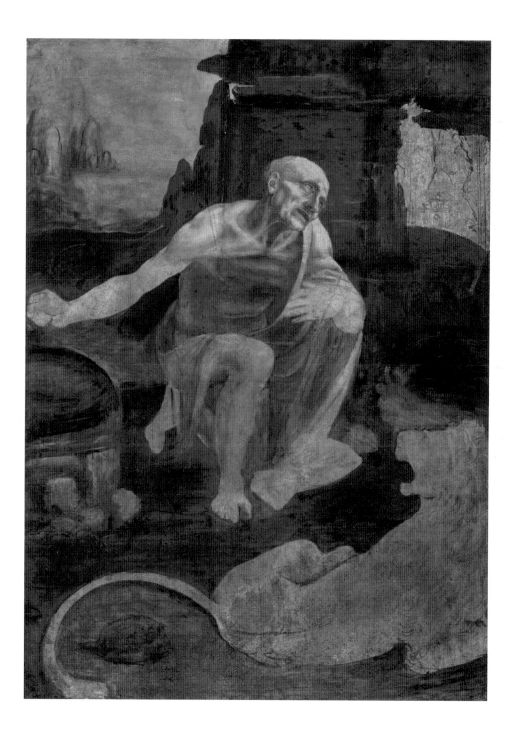

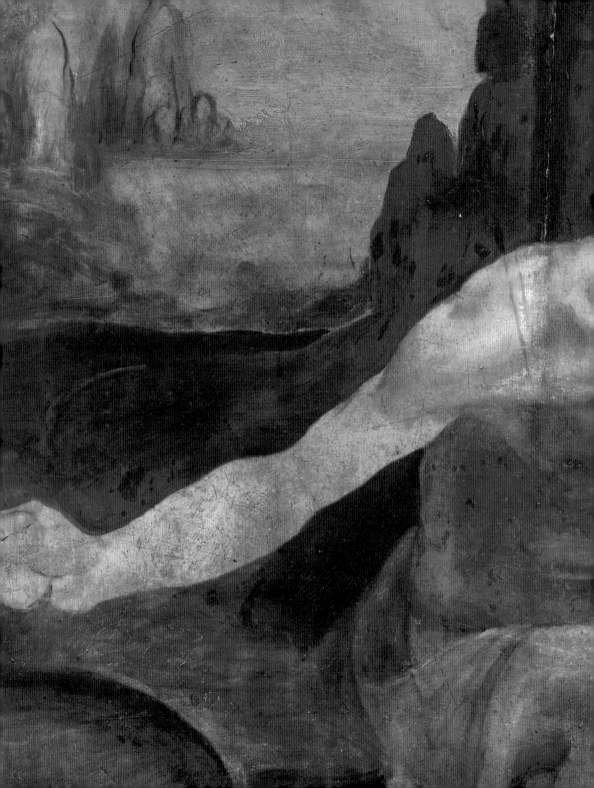

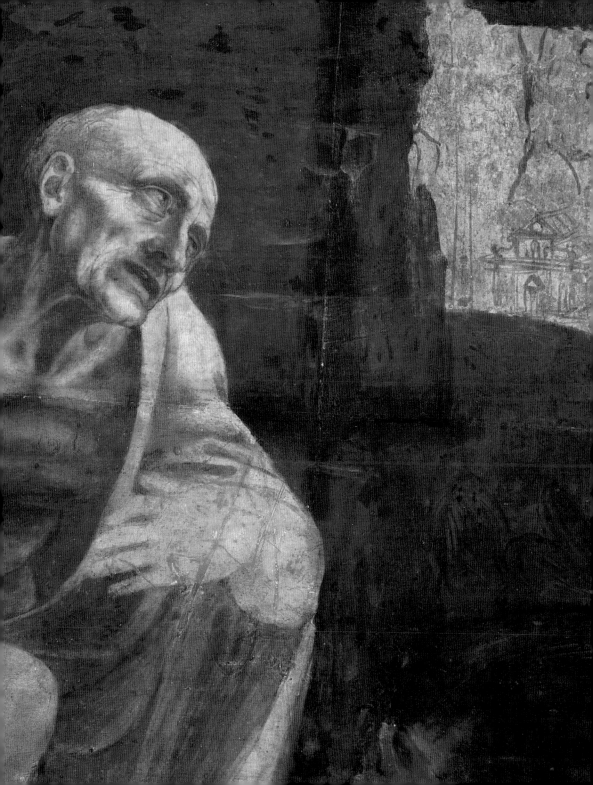

The Adoration of the Magi

1481–1482

Oil on wood, 246 x 243 cm
Galleria degli Uffizi, Florence

This altarpiece was commissioned in March 1481 by the monks of San Donato in Scopeto, close to Florence, but was never completed due to Leonardo's departure for Milan. It was left in the care of his friend Amerigo Benci, and later discovered in the collection belonging to Antonio de' Medici. On the death of his son Giulio in 1670, it passed into the Medici collection in the Uffizi. After a sojourn in the Villa di Castello, the painting returned to the Uffizi and was listed in the 1794 inventory.

Belonging to his first Florentine phase, this painting constitutes a summary of the technical and stylistic skills of the now thirty-year-old artist. Unfinished, it is a striking example of Leonardo's technique of using dark colors initially, to allow for the emergence of light through the subsequent layers of paint, and his use of white-lead highlights. This allowed him greater spatial depth. A good example of this is the dark-brown figure on the right, which lacks only the final layer of paint to be finished. In contrast, the figures and the architectural elements in the background remain mere sketches.

The traditional iconography of this Gospel story has here been completely overturned: this is a representation of an Epiphany full of agitation and consternation amongst the bystanders. In the center of the painting sit the Virgin and Child, a fulcrum of peace amid the chaos of gestures and movement. The turbulence surrounding the pair stretches back to the horsemen in the background, who are engaged in combat. On either side, closing the semicircle around the Holy Family, there are two standing figures: on the left, an old man in an attitude of contemplation, and on the right a young man whose face turns outwards, as if inviting the onlooker to join in meditation on the mysteries of the Incarnation.

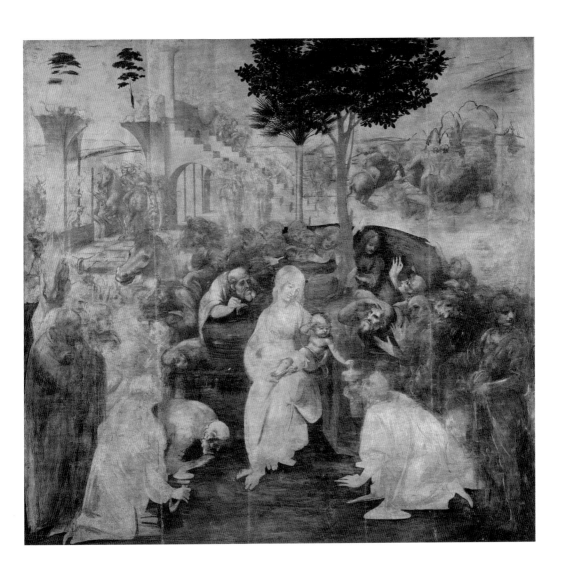

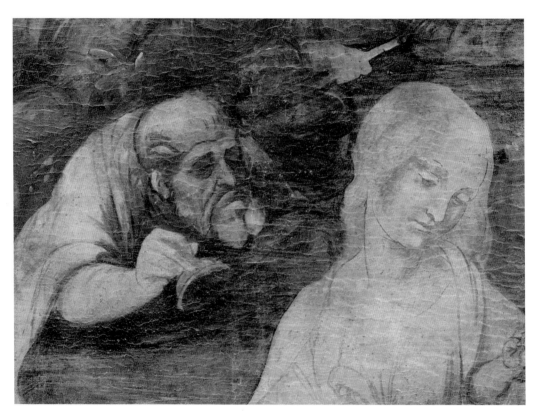

*The Adoration of the
Magi (details)*

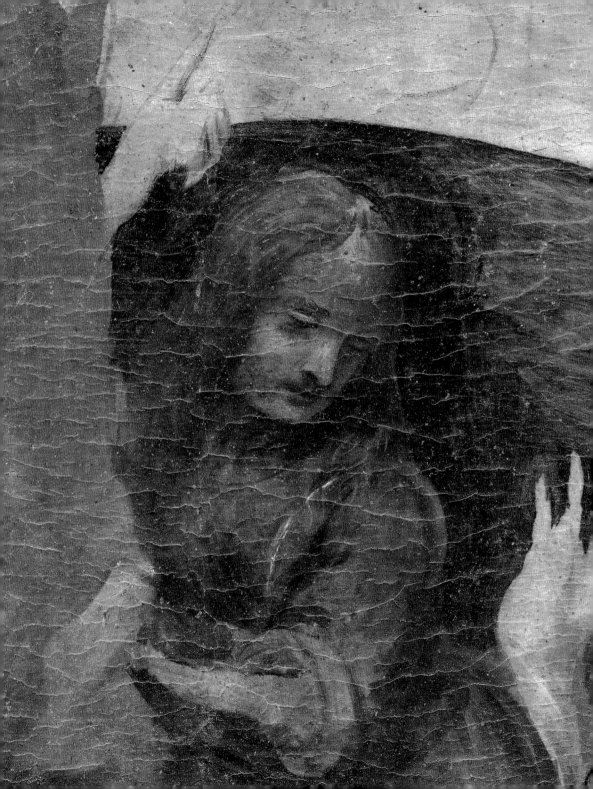

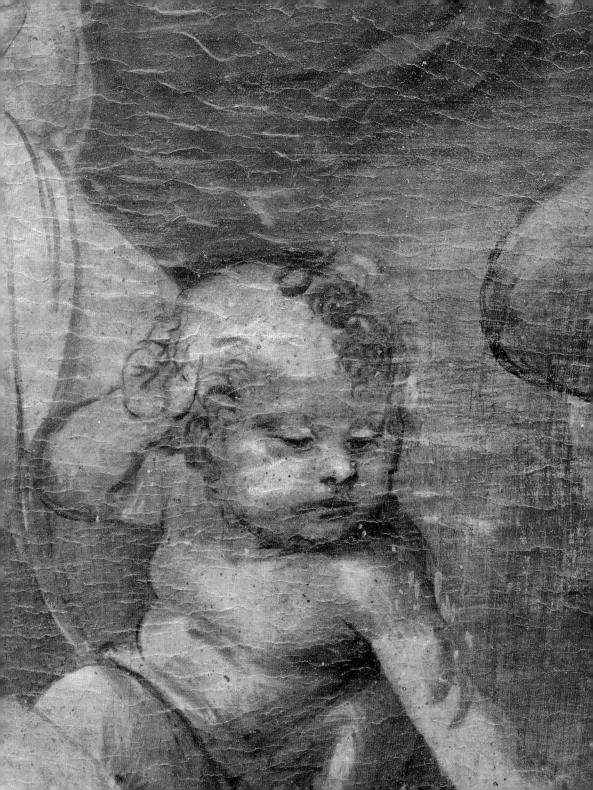

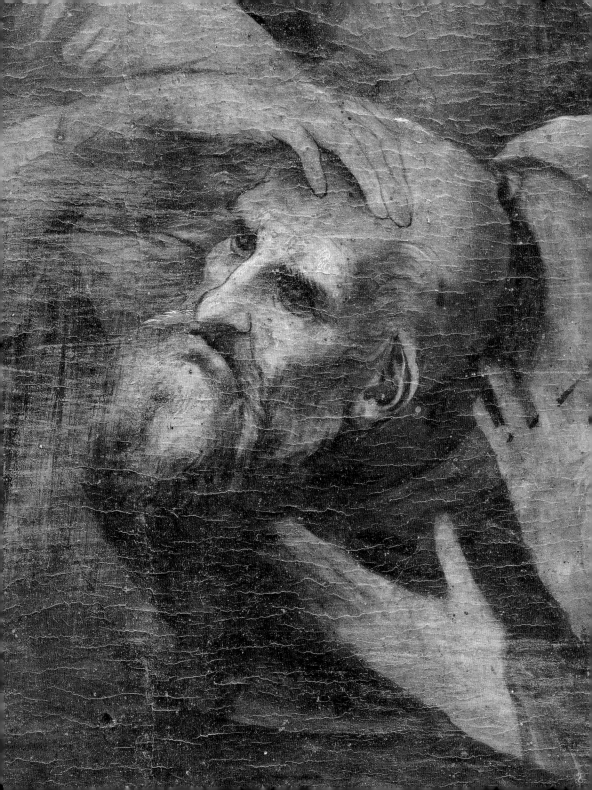

The Adoration of the Magi (details)

The Virgin of the Rocks

1483–1486

Oil on wood, transferred to canvas, 199 x 122 cm
Louvre, Paris

On 25 April 1483 the Milanese Confraternity of the Immaculate Conception of the Virgin
commissioned Leonardo to paint the central section of a polyptych for the altar of their
chapel in the church of San Francesco Grande. Giacomo del Maiano had been commissioned
to carve a wooden altarpiece with three main panels. The side panels were commissioned
from the brothers Ambrogio and Evangelista de Predis. A detailed contract was drawn up
concerning the panels, with an initial payment of 800 imperial *lire* (200 ducats).
The central panel was to portray the Virgin and Child surrounded by angels and prophets,
whilst the side panels were to show angels in glory. Instead, Leonardo decided to paint
an imaginary encounter between the infant Christ and the infant John the Baptist in the
wilderness, creating his own original iconography.
The background, rocky and damp, is full of plants and flowers depicted in botanical detail.
The Virgin is placed in the center, her right arm protectively around the infant Baptist in
prayer, whilst the sensuous figure of the angel, likened by art historian Carlo Pedretti to
a harpy, is seated next to the infant Christ, whose fingers are raised in blessing. Emerging
from the rocky obscurity, the four figures are bathed in soft light in a perfect example of
Leonardo's *sfumato* technique, which creates an atmosphere both of intimacy and calm
revelation. Legend has it that the painting did not satisfy the Confraternity, to such an extent
that it was never hung on the altarpiece. Whatever the truth, it is known for certain that the
painting was purchased by the French king Louis XII at the beginning of the sixteenth
century, and that Leonardo did in fact paint a second (very similar) version that was found in
the church when it was demolished in 1576, and that is now in the National Gallery, London.

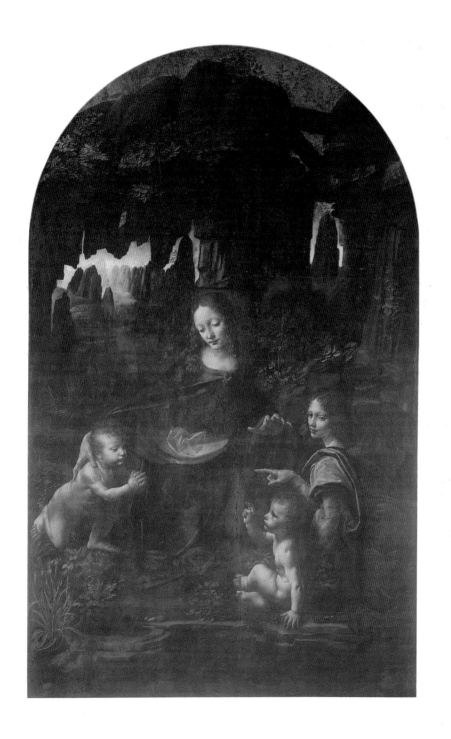

The Musician

c. 1485

Oil on wood, 44.7 x 32 cm
Pinacoteca Ambrosiana, Milan

This portrait is most likely of the musician and writer of musical treatises Franchino Gaffurio, who was choir master at the cathedral in Milan from 1484. From the mid-nineteenth century the portrait became wrongly associated with the *Portrait of a Young Woman* (Pinacoteca Ambrosiana, Milan), as part of a diptych showing the Duke and Duchess of Milan, Ludovico Sforza and Beatrice d'Este.

The half-length portrait shows the musician in pensive mood, the strong features of his striking face emerging from the darkness, illuminated from the right in a perfect balance of light and shade. The only touches of color are his scarlet cap and his coat, which were added later, though most probably also by Leonardo. The hand holding a scroll of music was also added later, but then painted over, remaining hidden until 1904. The partially erased lines "Cant... Ang..." found on the scroll helped in the identification of the subject: Franchino Gaffurio was known to be the author of a liturgical piece *Cantum Angelicum*. The descriptive force of the painting, the pupils of the eyes narrowing against the light, the touches of gold shining in his hair as it catches the light, and the introspective nature of the portrait (reflecting the portraits by the artist Antonello da Messina, who had visited Milan), are all elements that confirm that this can only be by the hand of Leonardo.

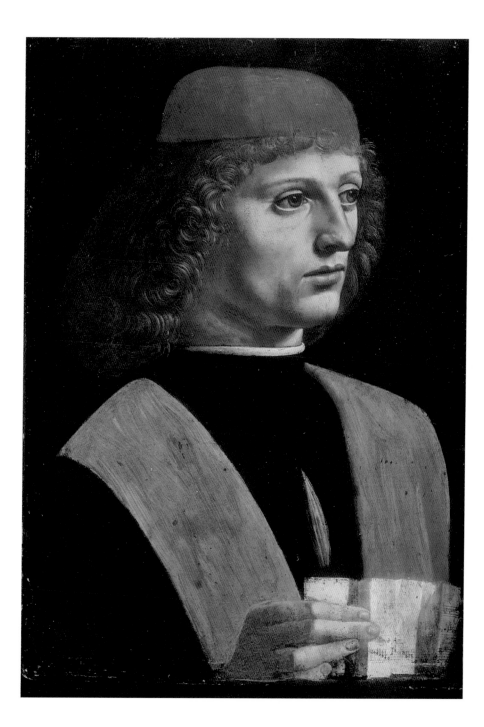

The Musician (details)

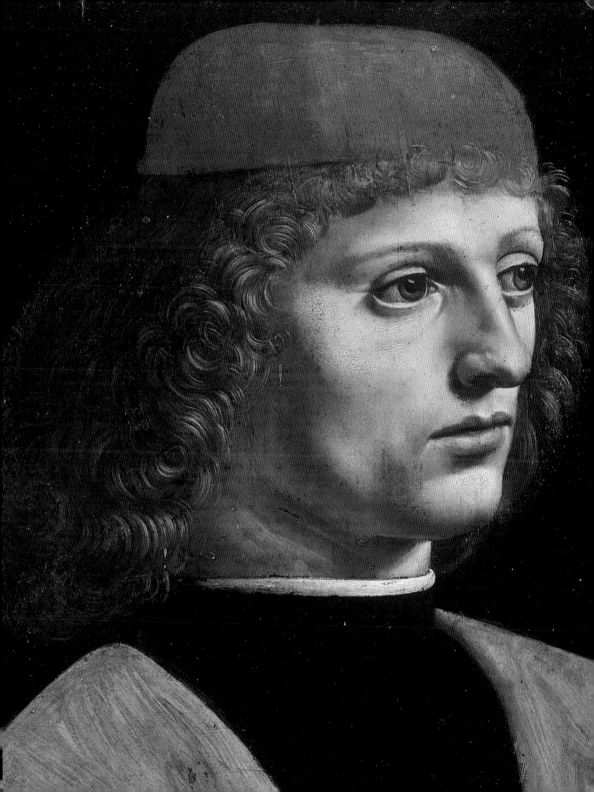

Lady with an Ermine

1488–1490

Czartoryski Museum, Cracow

Initially attributed to Ambrogio de Predis or to Boltraffio, there is now little argument as to the authorship of this painting. Thanks to the symbolic presence of the ermine (this in Greek transliterates as *galé*, meaning an ermine), the sitter has been identified as Cecilia Gallerani, the twenty-year-old lover of Ludovico Sforza. Bearing the faintest trace of a smile, her body twists gently in two opposing directions, face and torso, in subtle imitation of the animal she is holding. There are also similarities in expression and profile between them; the liveliness of the young woman's eyes is reflected in the playful gaze of the ermine, and the clear, sweeping lines of her figure are echoed in the long, smooth body of the ermine, whose pale coat has been painted in minute detail. The young woman's angular right hand seems both to caress and restrain the animal, whilst the sunlight streaming from what was once a window to the right of the painting (later painted over), unifies the composition and defines the space. Along with *The Musician* and *La Belle Ferronière*, this painting broke new ground in the Milanese artistic style and its tradition of portraiture. Made famous in a sonnet by Bernardo Bellincioni, the portrait was shown by Cecilia herself to Isabella d'Este, Duchess of Mantua. She was so impressed that she repeatedly asked Leonardo to paint her portrait, but all that remains is a preparatory sketch (see page 109).

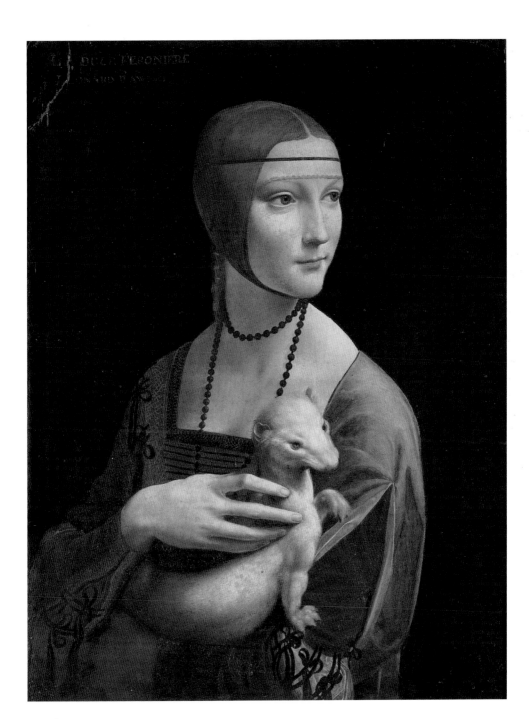

Vitruvian Man (Man in a Circle)

c. 1490

Pen and ink on paper, 34 x 24 cm
Gallerie dell'Accademia, Venice

Despite his penchant for experimentation and original research, Leonardo was an attentive student of ancient writings and classical thought. In his desire to understand the laws of nature, and to approach the art of painting in a scientific manner, he turned to the study of the ancients to help him to comprehend subjects such as anatomy, medicine, architecture, and botany. Particularly relevant in this context is this famous drawing, known as *Vetruvian Man*, which epitomizes Leonardo's carefully developed mathematical approach to artistic representation. He not only succeeded in realizing the canon of proportions drawn up by the Roman architect Vetruvius, but was also able to enlarge on them, drawing on his own anatomical, optical, and geometric knowledge, gained from his direct observation of and experimentation with the natural world. According to Leonardo: "In his treatise on architecture, Vetruvius maintains that man's proportions are designed by nature such that if a man lies on his back with his arms and legs outstretched, and if the point of a compass were to be placed on his umbilicus, a complete circle could be inscribed by touching the tips of his fingers and toes." For Leonardo, the greatest sign of divinity was harmony, and harmony could be discovered by observation underpinned by knowledge.

La Belle Ferronière

c. 1490–1495

Oil on wood, 63 x 45 cm
Louvre, Paris

There are various suggestions as to the identity of the sitter for this female portrait, such as Cecilia Gallerani, Beatrice d'Este, and Lucrezia Crivelli, none of which is particularly credible. In terms of style, composition, and color it resembles both *The Musician* and the *Lady with an Ermine*. The figure of the young woman is illuminated from above, and the use of chiaroscuro (contrasts of light and dark) emphasizes its tangible three-dimensionality. The slight turn of the body and head are the only indications of movement; the real dynamism of the painting lies in the expression of the eyes, which have darted to the right, following some movement unseen to the viewer. This lends a dramatic, psychological intensity to the portrait. Leonardo interpreted the eye as a powerful, introspective instrument, a true "window on the soul." Leonardo wrote: "The eye, in which the beauty of the universe is reflected; the eye, which can encapsulate all the works of nature. Visual contemplation is an act that has the power to free the spirit from its human prison, and transport it into other realms. Without it, the soul is left in a dungeon of darkness, deprived of light and hope ... The beauty of the world consists in the surface of things both natural and artificial, and these surfaces are reflected in the human eye" (*Treatise on Painting*).

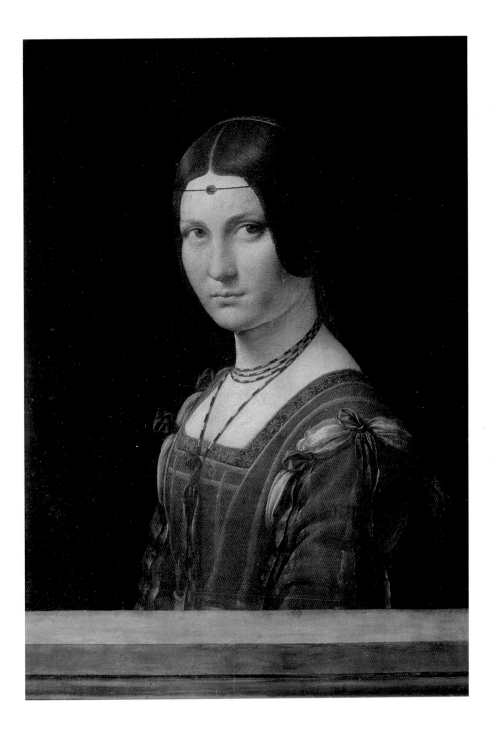

The Virgin of the Rocks

1494–1508

Oil on wood, 189.5 x 120 cm
National Gallery, London

This painting is the second version of *The Virgin of the Rocks*, which was originally painted between 1483 and 1486 for the church of San Francesco Grande in Milan, and which is now in the Louvre (see page 73). It seems likely that the London version was painted in two distinct phases, the first being in the last decade of the fifteenth century, and the second between 1506 and 1508. The work has traditionally been held to be painted jointly by Leonardo and Ambrogio de Predis, but recent research suggests that it is predominantly the work of Leonardo, albeit with some assistance. The figures, comprising the Virgin and Child with the young St. John and an angel, are painted in monumental form, with a single color tonality washing over the whole. The landscape differs slightly from that in the Paris version, and seems designed to draw the eye of the viewer successively deeper into the background, whilst the group of figures seems to project forward out of the canvas. This new compositional device would later be used to great effect in the *Last Supper*, painted for the refectory of Santa Maria delle Grazie in Milan.

The painting, which was never finished in the lower section, must have existed at least in some distinguishable form by 1503, as testified by a miniature copy of it by Antonio da Monza (Albertina, Vienna). The painting remained in the collection of works that had once belonged to the banned Confraternity of the Immaculate Conception of the Virgin, and in 1785 it was sold by the administrator of the collection, the Count of Cicognara, to the British painter Gavin Hamilton for the sum of 112 Roman *zecchini*. The following year it was sold to Lord Lansdowne, then later to Lord Suffolk, and finally it was left to the National Gallery in London in 1880.

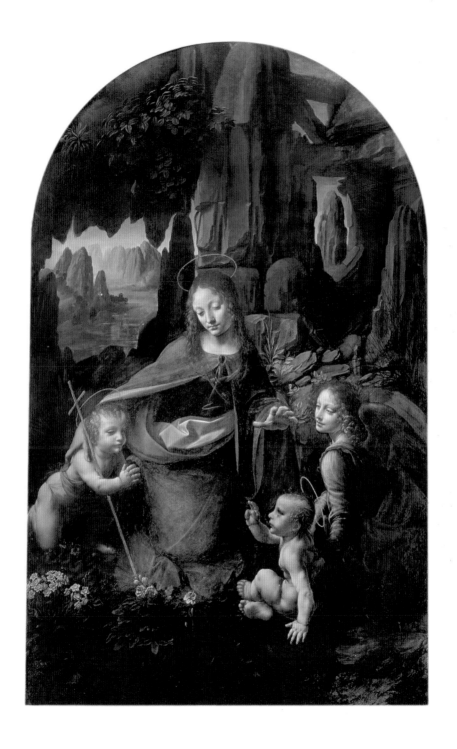

The Virgin of the Rocks
(details)

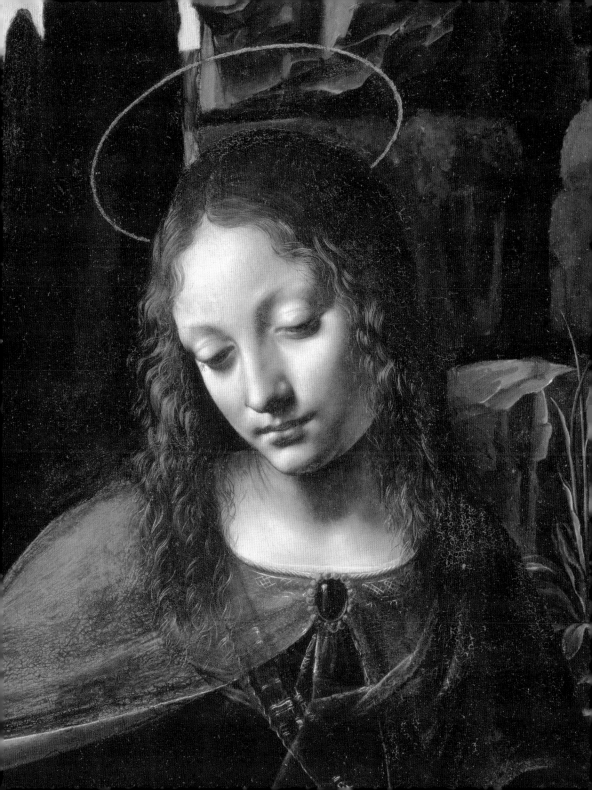

Head of Christ

c. 1494

Chalk and pastel on paper, 40 x 32 cm
Pinacoteca di Brera, Milan

Despite its poor state of preservation, this drawing in the Pinacoteca di Brera is generally accepted to be by Leonardo, though it was altered posthumously by the addition of some hatching designed to clarify the outline of the face and the strands of hair. It was common among young painters to emanate the works of the great masters such as Michelangelo, Raphael, and Titian.

It seems likely that this head of Christ was intended as a preparatory sketch for his monumental *Last Supper*, where Christ is set in the center of the scene, isolated and serene amidst the consternation of his disciples. If this supposition is correct, then an important modification was made to the Brera design before it was transferred to the wall. The preparatory sketch shows Christ's head tilted to the right, with eyes closed, cheeks faintly colored, and lips together. In the painted version in Santa Maria delle Grazie (see page 93), his lips are apart, having just uttered the tragic words "Truly, truly, I say to you, that one of you shall betray me." The effect of these prophetic words is rippling through the disciples, causing a variety of reactions and gestures. What began as a simple meal has become a dramatic turning point in the Christian story.

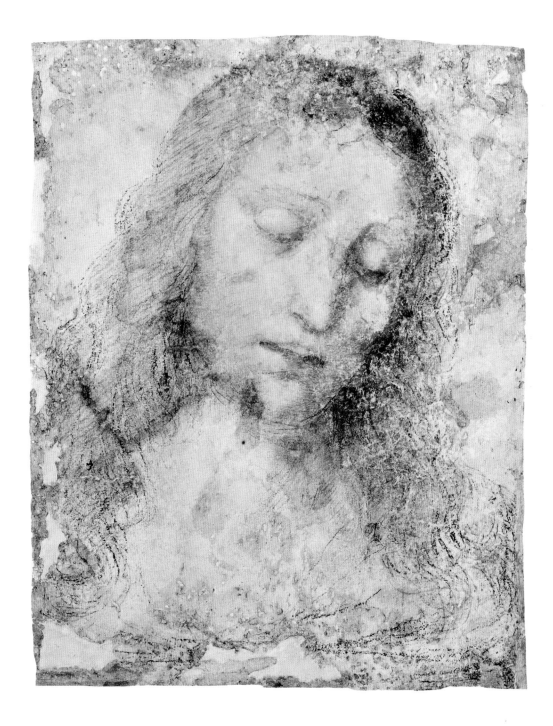

The Last Supper

1495–1498

Oil on wall, 460 x 880 cm
Refectory of Santa Maria delle Grazie, Milan

This monumental work was created for the refectory of the convent of Santa Maria delle Grazie in Milan. What is most striking about it, particularly after the latest restoration project (1978–1999), is its single perspective structure, despite the breadth of its composition. An earlier example of this can be found in the Uffizi *Adoration of the Magi*. This has the effect of harmonizing the multiplicity of movements and expressions in a work in which each individual figure portrays a different emotion: astonishment, agitation, incredulity, bewilderment, grief, resignation. Every detail has been portrayed meticulously, and even the objects on the table seem to participate in the scene: knives, plates, glasses, pieces of bread are involved in the movements of the disciples, who are grouped into threes. Only the consummate skill of Leonardo could produce a work in which complex and turbulent individual reactions are portrayed without losing the unity and harmony of the whole. The painting is rich in theological symbolism, with references to the Eucharist and to the Redemption of mankind. The protagonist of the scene is clearly Christ, seated in the center, isolated from the surrounding groups of disciples both physically and emotionally in his calm, sad resignation to what is to come. All the action emanates from this peaceful center. The work was commissioned by Ludovico Sforza, and became immediately renowned, despite its poor state of preservation, a fact that was already in evidence by the beginning of the sixteenth century. This was largely due to Leonardo's dislike of the inflexibility of fresco technique and his preference for oil painting, which is not well-suited to wall painting.

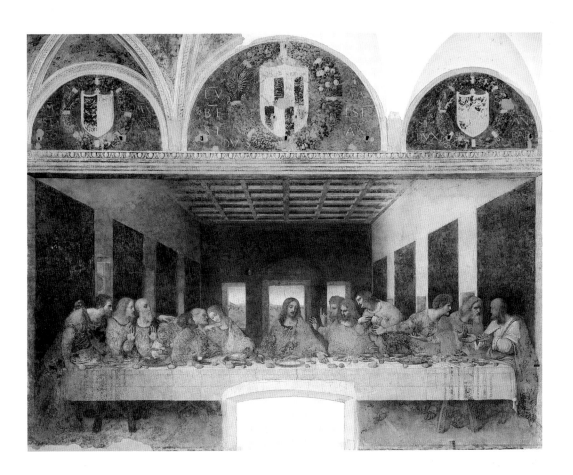

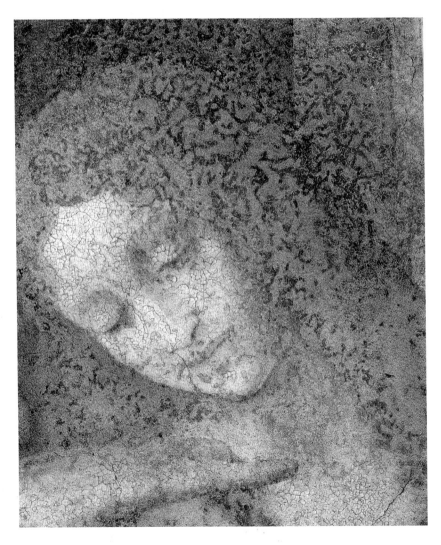

The Last Supper
(details)

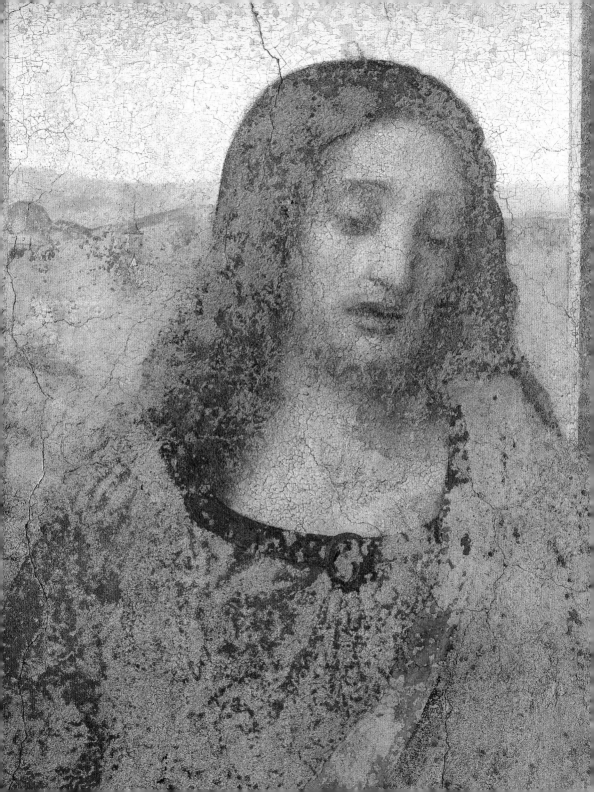

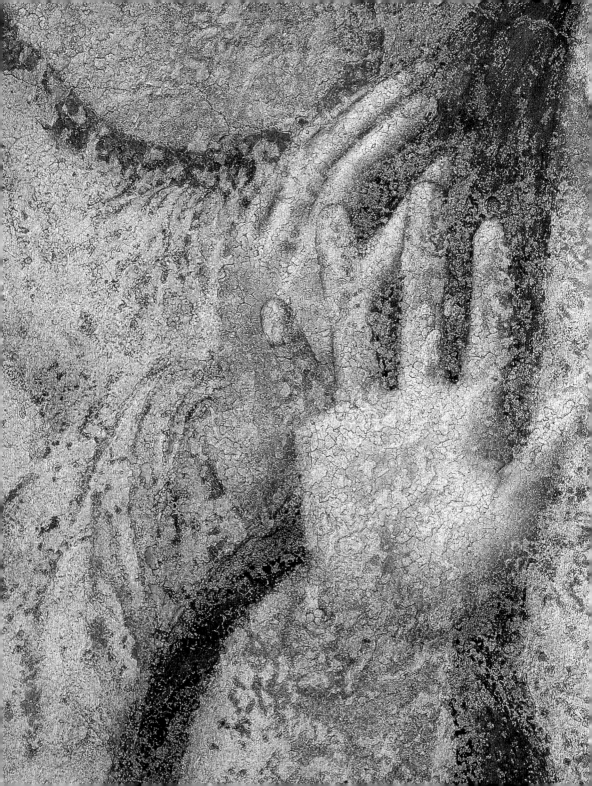

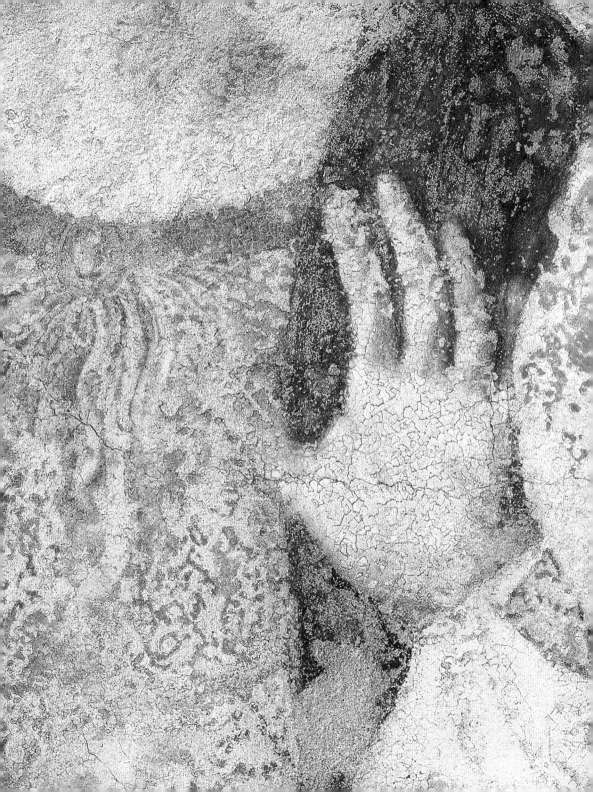

The Last Supper
(details)

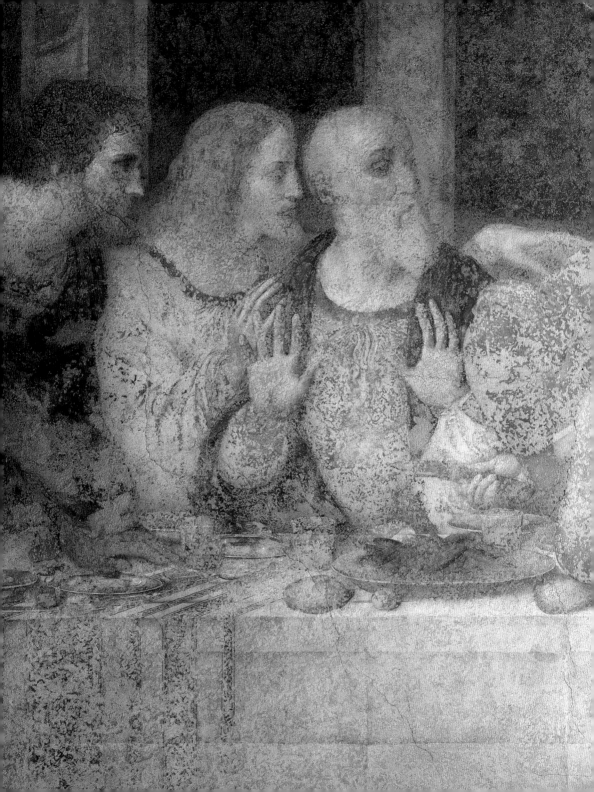

Portraits of the Duke and Duchess of Milan with Their Sons

1497

Tempera and oil on plaster, base approx . 90 cm per pair of figures
Refectory of Santa Maria delle Grazie, Milan

It was Vasari who claimed that Leonardo had inserted two pairs of figures either side of the Crucifixion that was signed and dated by the painter Giovanni Donato di Montorfano in 1495, on the wall facing the *Last Supper* in the refectory of Santa Maria delle Grazie. "While he was working on the *Last Supper*, in the same refectory on the end wall where there is a painting of the Passion done in the old way, he portrayed Ludovico [Sforza] himself with his eldest son Massimiliano, and on the other side the Duchess Beatrice with his other son Francesco, both of whom later became dukes of Milan, all of them beautifully painted." Today there remain only a few fragments of the original, which, due to the bomb that struck the refectory in 1943, and also to the technique Leonardo used, simply did not survive. Giacomo Girolamo Gattico (seventeenth century), in his description of the convent, blamed Ludovico Sforza for the erroneous choice of technique: "Leonardo painted ... the duke and the duchess whom we see by the side ... and those portraits have decayed because they were painted in oils, against the painter's will, but on the order of Duke Ludovico."
The true authorship of the figures has always been in dispute, despite the documentation, but more recent scientific studies seem to confirm that they were indeed painted by Leonardo. In addition to the evidence provided by writers such as Vasari, Gattico, and Lomazzo, there is a letter from Ludovico Sforza to the son of Marquis Stanga dated 29 June 1497 in which he expresses his concern that Leonardo should hurry and finish the Last Supper in the refectory so that he could turn his attention to the facing wall.

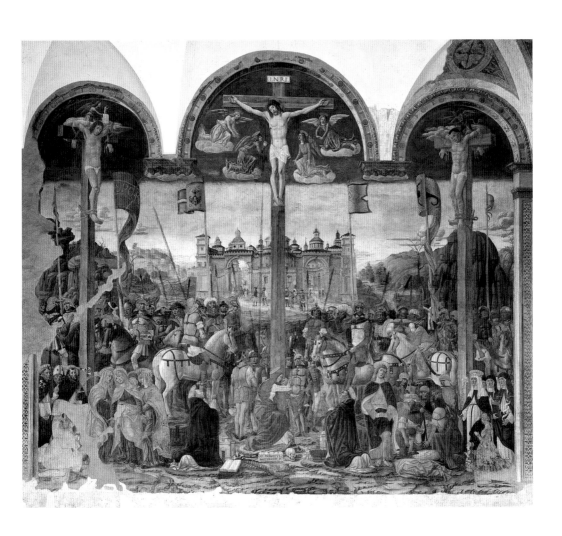

Interlacing Branches

c. 1498

Wall paintings heavily painted over in 1901–1902
Sala delle Asse, Castello Sforzesco, Milan, vault and north-east wall

In a letter from Gualtiero Bescabé to Ludovico Sforza in 1498, Bescabé tells the Duke that Leonardo's decorative work in one of the rooms in the Castello Sforzesco should be completed during September. Fragments of painting showing interlacing branches were discovered in the Sala delle Asse when whitewash was removed from the ceiling in 1893, but a few years later the vaulted ceiling was "restored" with a heavy over-painting that obscured the original scheme by Leonardo. It was not until the mid-1950s that a new campaign of restoration uncovered more of this extraordinarily naturalistic composition of intertwining leaves and branches, which transformed the cold vaulted ceiling of a castle into a rich, magical canopy. The restoration work also brought to light a small fragment on the east wall consisting of a cluster of rocks rising from the floor, twisted roots, and a tree trunk rising towards the vault, one of the many trees whose branches would have climbed up and over the ceiling, covering it entirely. It was an iconographic concept "in the round," creating a vibrant, all-encompassing sense of nature. Leonardo was profoundly interested in the natural world, and this complex composition incorporates many of the ideas formulated in his *Treatise on Painting*, which contains a whole chapter dedicated to trees and vegetation.

Isabella d'Este

c. 1500

Black chalk, sanguine, and yellow pastel on paper, 63 x 46 cm
Louvre, Paris

After the fall of Ludovico Sforza in 1499, Leonardo left Milan to return to Florence, stopping at Mantua and Venice on the way. In Milan he stayed with Isabella d'Este, the wife of Gian Francesco Gonzaga. He is reputed to have sketched two portraits of her, one of which remained in Mantua but was given away as a gift by Gonzaga in 1501 and disappeared without trace, whilst the other accompanied Leonardo on his journey to Venice. In 1498 Isabella d'Este had been much impressed by the portrait *Lady with an Ermine*, which Cecilia Gallerani had shown her in Milan. She was anxious to have her portrait painted by Leonardo in order to compare him as an artist with Giovanni Bellini, and she repeatedly asked to sit for him. In the early twentieth century, this drawing by Leonardo was identified with the painting commissioned by Isabella d'Este: the perforations along the lines of her dress and her right hand—made so that when the drawing was dabbed with chalk or charcoal the image could be transferred to a panel or canvas—indicate that this was probably a preparatory study for the long-awaited portrait of the Duchess of Mantua. Executed in sanguine and black chalk, the drawing shows the face of Isabella in profile, the bust facing forwards, and the hands crossed in a pose that some have suggested may be a forerunner to that in the *Mona Lisa*. The delicate lines of the face have been modeled in soft chiaroscuro, whilst the elegant dress and its decorative ribbons have been accentuated by a light touch of yellow pastel.

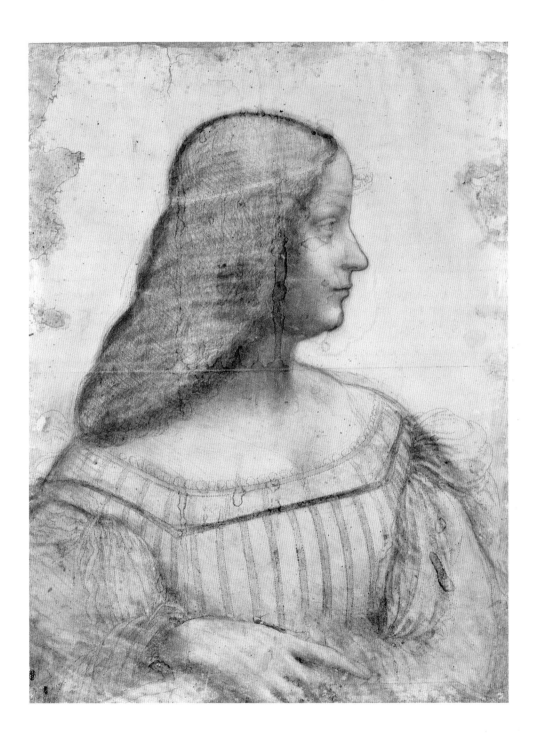

Madonna and Child (Madonna of the Yarn Winder)

c. 1501

Oil on wood, transferred to canvas, 50.2 x 36.4 cm
Private collection, New York

Fra Petro da Novellara, writing to Isabella d'Este on 14 April 1501, mentions that at the beginning of the sixteenth century Leonardo was working on a painting of this subject, which had been commissioned by the Secretary of State to Louis XII of France, Florimond Robertet. He describes "a small picture that he painted for a certain Robertet, a favorite of the King of France ... a Madonna sitting as if she meant to wind a spindle, whilst the child, his foot over a small basket, has picked up the yarn winder and is gazing at the four arms that make up the shape of a cross, smiling eagerly at the cross and holding it fast, refusing to give it back to his mother, who is trying to take it away from him."

There has been considerable disagreement over the authorship of the painting, but more recent evidence seems to suggest that Leonardo was involved, albeit with many assistants. In addition to the numerous posthumous variants painted by pupils and other artists such as Franciabigio, Raphael, and Sodoma, who presumably worked from sketches or designs that no longer exist, there is a second version that was in the collection belonging to the Duke of Buccleuch in Drumlaring Castle in Scotland. Stolen from the castle in 2003, it was recovered and is now in the National Gallery of Scotland in Edinburgh. This version would appear to be predominantly the work of pupils, with limited intervention by the master. Despite the ambiguity and controversy surrounding this painting, it is clear that Leonardo was constantly searching for new iconographic models and experimenting with different ways to explore the unique relationship between Mother and Child.

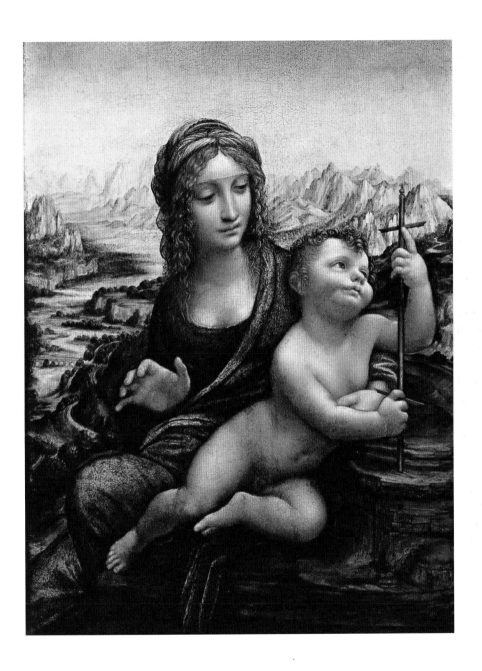

The Virgin and Child with St. Anne and St. John the Baptist (Burlington House Cartoon)

c. 1499–1500

Black chalk, heightened with white, on paper, 141.5 x 104.6 cm
National Gallery, London

There is hardly any detailed documentation concerning the origin and the commissioning of this cartoon. Only a letter from Padre Resta to Gian Pietro Bellori throws some light on the subject: "Before 1500, Louis XII commissioned a cartoon of St. Anne from Leonardo da Vinci, who lived in Milan: Leonardo made a first sketch that is now in the house of the Counts Arconati in Milan." Although it is difficult to verify the supposed commission from Louis XII, it is certain that the sketch now in the National Gallery in London is the one that Resta spoke of in his letter. It passed from the Arconati family to the Casnedi in 1721 and from them to the Sagredo collection in Venice; there, it was acquired in 1763 by Robert Udny, and a few years later is mentioned in an inventory of the Royal Academy in London. It was finally bought by the National Gallery in London in 1962.

The group of figures, comprising St. Anne, the Virgin, the infant Christ and the young St. John, is one of the clearest examples of the influence classical sculpture had upon Leonardo's development. There is a strong possibility that he may have been inspired by a particular classical sculpture, that of the Muses in the Villa Madama in Tivoli, which he visited in March 1501. There are several sketches that seem to suggest this, along with the style of voluminous drapery, the strong modeling of the figures, and the fact that one of the figures seems to be without arms, like the statues at Tivoli before restoration. On the other hand, the use of chiaroscuro and the delicate layering of color would seem to suggest a progressive rather than retrospective move towards the greater sense of atmosphere and psychological depth that characterize Leonardo's mature works.

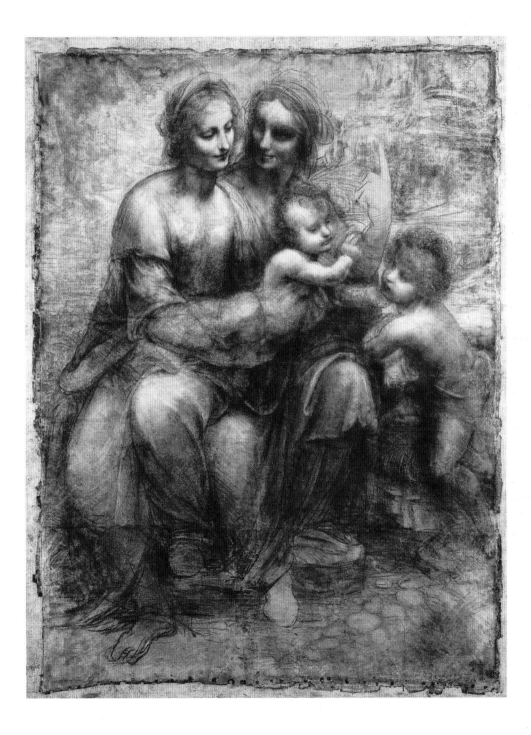

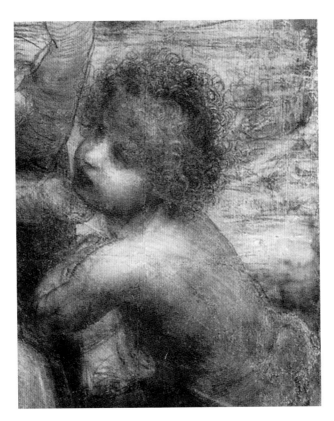

*The Virgin and Child
with St. Anne and
St. John the Baptist
(Burlington House
Cartoon) (details)*

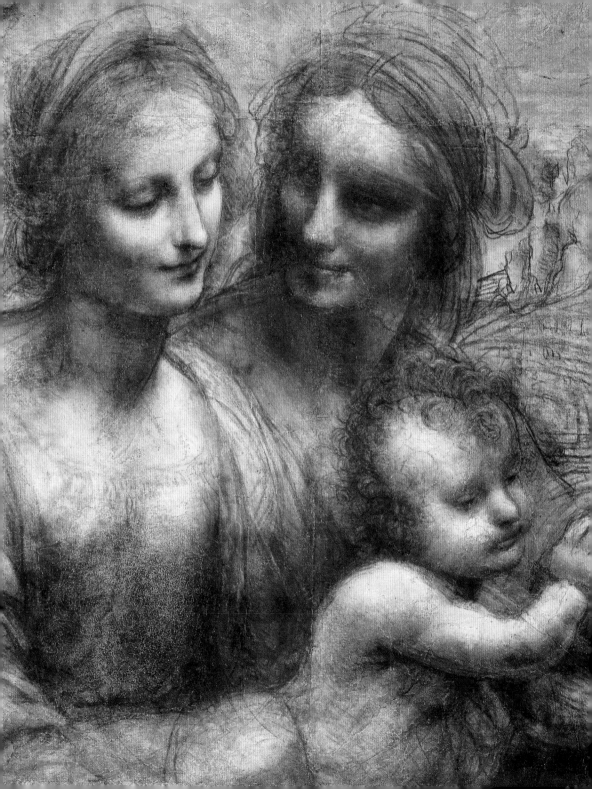

Mona Lisa (La Gioconda)

1503–1514

Oil on wood, 77 x 53 cm
Louvre, Paris

It is undoubtedly the most famous painting in the world, and has been variously described as enigmatic, ambiguous, ironic, and sensual. It has been applauded, idolized, imitated, quoted, and satirized; Marcel Duchamp and Andy Warhol are just two modern artists who have appropriated the image for their own ends. Although over-familiarity can sometimes cloud judgment, this portrait of Lisa Gherardini, wife of the Florentine merchant Francesco del Giocondo, is an undisputed masterpiece. The painting possesses an extraordinary psychological introspectiveness, is a perfect example of painterly skill (there are no visible brushstrokes), is pervaded by a unique atmosphere, and the background has been rendered with painstaking attention to detail. Writing in 1989, Pietro Cesare Marani described the painting as "an image encapsulating the poetic artistry of Leonardo: the figure of the lady, who is seated on an upper storey loggia, dominates the distant landscape, a composition that was typical of the style common to humanist Italian portraiture, such as Piero della Francesca's portrait of the Duke and Duchess of Urbino in the Uffizi (c. 1472). However, in terms of atmosphere, the subtle use of light, and the gentle inclining of the three-quarter-length figure towards the viewer, this painting marks a turning point between the old, heraldic style and the more naturalistic style of portraiture that characterized the later Renaissance. The painting, which is a work of technical perfection, seems to transcend the boundaries of time and space. That ambiguous smile creates a scarcely perceptible sense of movement across the face, and forms the focus of the incredible luminosity which pervades the face of the woman."

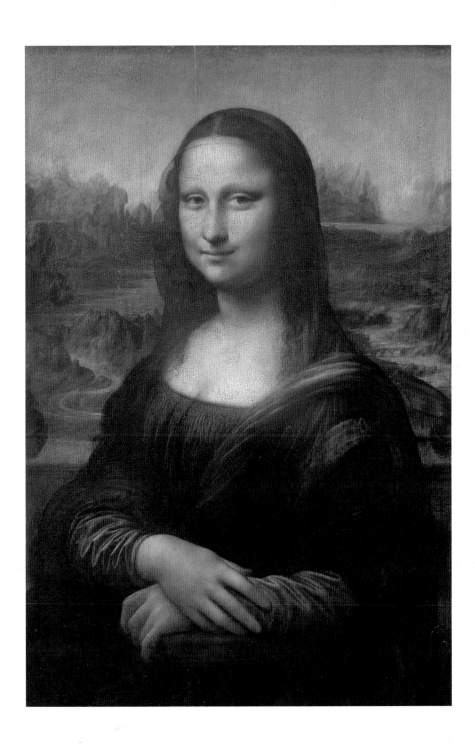

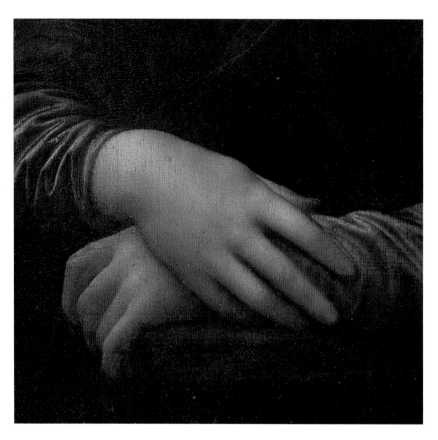

Mona Lisa (La Gioconda)
(details)

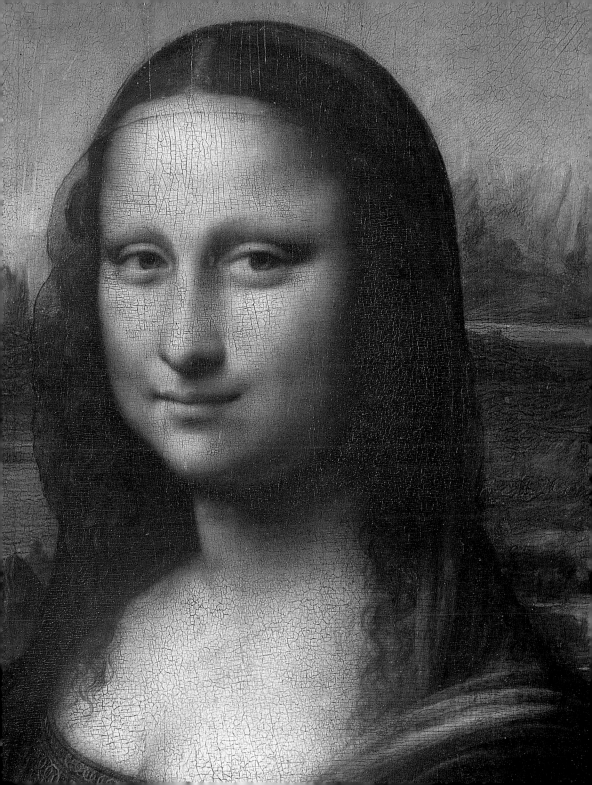

Head of a Young Woman (La Scapigliata)

c. 1508

Umber, terra verde, and white lead on wood, 24.7 x 21 cm
Galleria Nazionale, Parma

This drawing was listed in a Gonzaga inventory of 1627 as "a picture representing the head of a disheveled woman, a rough sketch ... the work of Leonardo da Vinci." It has been identified as the painting that Ippolito Calandra, in 1531, wanted to place in the bedroom of Margherita Paleologa, wife of Federico Gonzaga. It has also been suggested that this is the same work alluded to in a letter written by Isabella d'Este to Fra Pietro da Novellara, dated 27 May 1501, in which she asks him to commission a painting of the Madonna from Leonardo for her private collection.

The work was left unfinished, and has been linked with studies for the *Adoration of the Magi* and *St. Jerome*, though recent studies have concluded that it is a more mature work that could be placed alongside paintings like *The Virgin of the Rocks* (Louvre, Paris, and National Gallery, London) and the *Virgin with St. Anne* (National Gallery, London). The sketch is sculptural in form and elegant in line. Her full lips are smiling slightly, her nose elongated, her face rounded and her eyes pronounced, as they gaze tenderly downwards. The refined, angelic face is contradicted by the tumbling locks of disheveled hair, which suggest rather more wildness of spirit, a juxtaposition that corresponds beautifully to Leonardo's own poetic vision.

St. John the Baptist

1508–1513

Oil on wood, 69 x 57 cm
Louvre, Paris

The young St. John seems to spiral towards us out of the inky, impenetrable blackness. There are no spatial references, only layers of darkness into which every trace of brushwork has vanished. Leonardo is clearly using this iconographic invention to continue his own experiments: the rippling, flowing curls of the saint's hair bring to mind the studies of the movement of water in which he was engaged in at the time, a fact that confirms the unity of his artistic vision. He frequently used his scientific observation to enhance his pictorial representation: in this case the ripples of hair are portrayed so convincingly that not only do they frame the face, they also seem to hang heavily. The light reflected in the hair also brightly illuminates the face of the saint, who wears the languid, sensual expression typical of Leonardo's mature work. The ambiguity of this expression has given rise to numerous allegorical interpretations of a classical or pagan nature, but the biblical reference is clear: the humble cross made from sticks and the finger pointed heavenwards announce the Coming of Christ and the Resurrection. Probably the result of a commission from Giovanni Benci, the painting was seen in Leonardo's workshop in Cloux in France in 1517. It was sold by the descendants of Salaì, Leonardo's pupil, and ended up in the hands of the banker Everhard Jabach, who sold it to Louis XIV of France in 1666. Later it was handed to the Louvre.

Head of Leda

c. 1510

Red chalk on paper, 20 x 15.7 cm
Civiche Raccolte d'Arte, Castello Sforzesco, Milan

This sketch has long been attributed to Cesare da Sesto, who painted the figure of Leda in the Pembroke Collection in Wilton House in England. It was not until 1980 that Carlo Pedretti claimed that it was by Leonardo, an attribution corroborated in 1983 by Alessandro Vezzosi. This preparatory sketch of the head of Leda, which is among the most precious items in the collection in the Castello Sforzesco, was one of many studies made by Leonardo for his *Leda*, a lost painting is known only by its imitations, such as the one by Cesare da Sesto, and the one by an unknown painter in the Uffizi, Florence. Leonardo's painting was seen in 1625 in Fontainebleau by Cassiano del Pozzo, already in a much deteriorated state: "A Leda standing, almost completely nude, with at her feet the swan and two eggs, from which four babies have come out. It is somewhat dry in style, but exquisitely finished, particularly the woman's breast. The landscape and foliage are represented with great diligence. But it is in a bad state since it is made up of three panels that have split apart and the painted surface has been broken."

Although the original painting has been lost without trace, we can be sure that it was much admired by Leonardo's contemporaries, given the large number of imitations. Leonardo himself devoted many studies to the theme, experimenting with the posture of the female figure, seated or standing, the flowers at her feet, and the intricate coiffure of her hair.

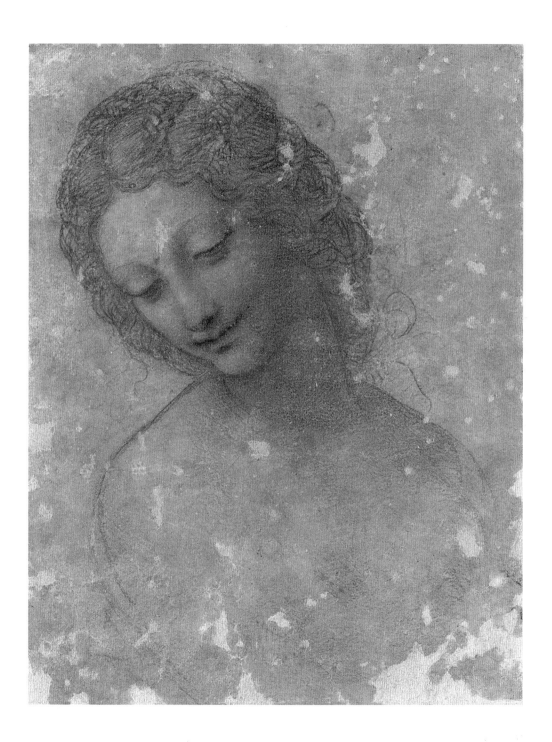

Virgin and Child with St. Anne

c. 1510–1513

Oil on wood, 168 x 130 cm
Louvre, Paris

This painting was preceded by at least two different versions, the cartoon that is now in the National Gallery, London (see page 113), and the cartoon mentioned in a letter dated 3 April 1501, written by Fra Pietro Novellara to Isabella d'Este: "[Leonardo] depicted a Christ Child about one year old, who strains from his mother's arms to grab and hug a lamb. The Virgin, raising herself from St. Anne's lap, holds the Child and tries to pull him away from the lamb. St. Anne, slightly raising herself, seems to want to prevent her daughter from separating the Child from the lamb."

The Louvre version shows many similarities to the cartoon described by Novellara. The complex composition, which is full of allegorical significance, is based on a pyramidal construction, consisting of the Christ Child, determined to play with the lamb, a prefiguration of Christ embracing the Passion; the Virgin, who instinctively tries to restrain her son; and St. Anne, here representing the Church, who allows the Child to continue playing. The suffused light, the delicate layers of color, and the rugged mountains receding into the mist on the horizon all accentuate the three-dimensionality of the central figures. The subtlety of movement and expression, the sense of height and depth, and the careful balance of lines make this a monumental painting, if somewhat less classical than the cartoon in the National Gallery in London.

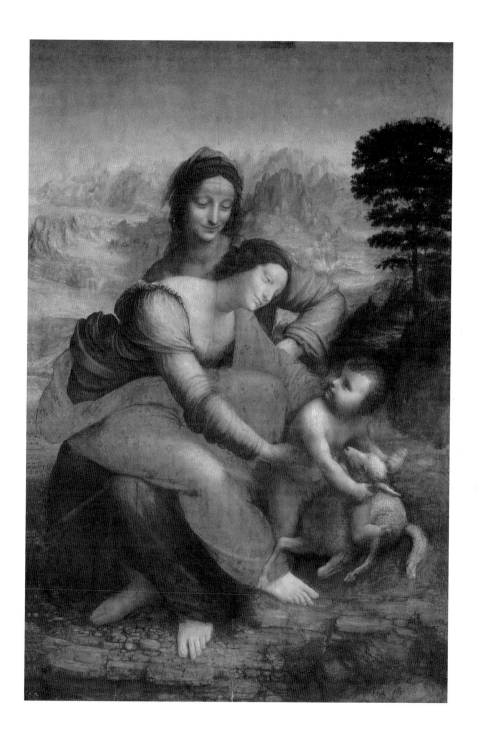

Virgin and Child with
St. Anne (details)

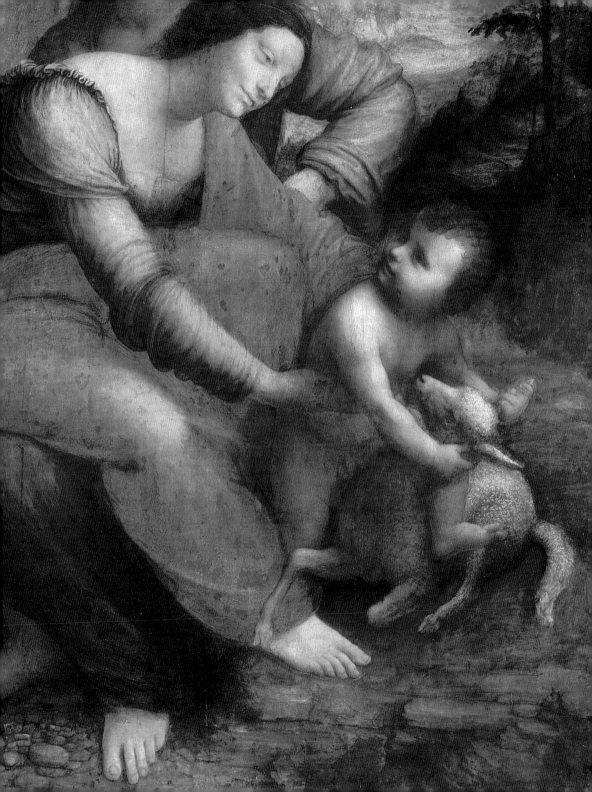

Bacchus (Formerly St. John the Baptist)

1510–1515

*Oil on wood, transferred to canvas, 117 x 115 cm
Louvre, Paris*

Critics have always been divided on the subject of this painting, and on the degree of
Leonardo's participation. It has been attributed to pupils and followers of the master, such
as Bernazzano, Cesare da Sesto, and Francesco Melzi, but these days it is generally
accepted that the concept of the composition was Leonardo's, likewise the characteristic
use of color and chiaroscuro (contrast of light and dark). The originality and ambiguity of the
theme has convinced many scholars that it is basically the work of Leonardo, but with some
assistance. The work bears all the hallmarks of Leonardo's traditional iconography for
St. John the Baptist, but it seems that the subject was transformed into the pagan god
somewhere between 1683 and 1695, with the addition of the panther skin and the crown of
vine-leaves, the cross being turned into a thyrsus. In the Paillet catalogue of 1695, the title
"St. Jean au desert" (St. John in the Desert) was crossed out and replaced with the title
"Bacchus dans un paysage" (Bacchus in a Landscape). The innovative energy of the
composition and the articulation of the figure resemble that of the St. John the Baptist in
the Louvre (see page 123), and in addition there exists a small red chalk drawing of a
similar St. John in the Sacro Monte Museum in Varese, dating from 1511–1515, which
Charles de Tolnay has attributed to Leonardo.

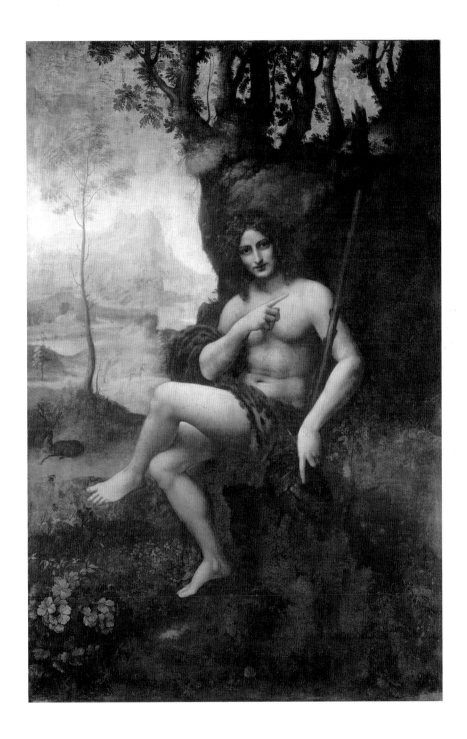

Bacchus (Formerly
St. John the Baptist)
(details)

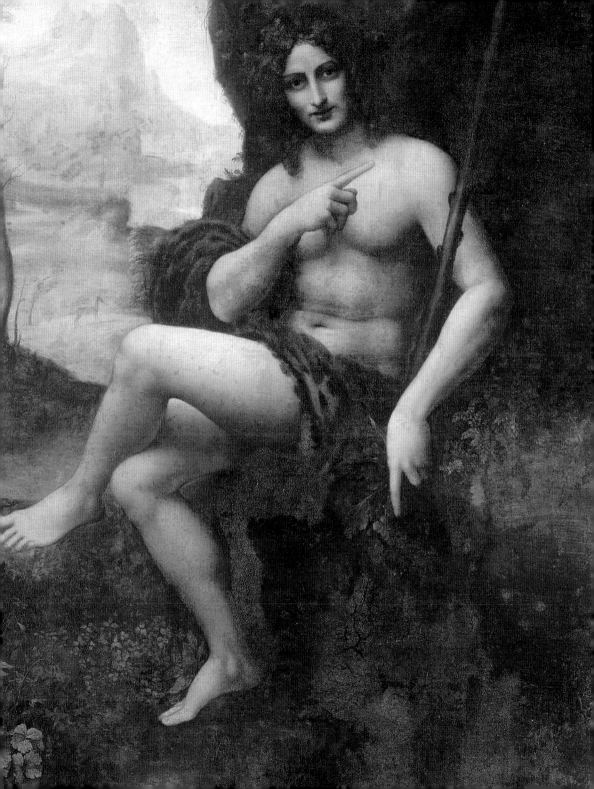

Self-Portrait

c. 1515

Red chalk on paper, 33.5 x 21.3 cm
Biblioteca Reale, Turin

This red chalk drawing is the only identified self-portrait by Leonardo, and over the centuries it has imprinted an image of Leonardo as an old man upon the collective mind, giving rise to many imitations. There are only a few indications of what he may have looked like as a young man or in middle-age: in his *Adoration of the Magi*, the young man standing on the far left is said to be a self-portrait and Verrocchio's bronze *David* (1473-1475) in the Bargello, Florence, is a presumed portrait of him, as is the figure of Plato in Raphael's *School of Athens* (1510-1511). There are several written records that mention his appearance, and whilst not detailed they give a general idea of how he looked. He was, apparently, quite handsome. The writer known as Anonimo (Anonymous) Gaddiano, for example, waxes lyrical about him (1537–1542): "He was a rare and exceptional being, a very miracle of nature, not just in the beauty of his body, but in the many virtues he possessed ... he was pleasing to look at, well-proportioned, gracious and handsome. He wore a rose-colored cloak that reached only to his knees, though at the time long vestments were the custom. His beard came to the middle of his chest and was well-combed and curled." Vasari describes his amiable character: "His magnificent presence brought comfort to the most troubled soul; he was so persuasive that he could bend other people to his will. He was physically so strong that he could withstand violence ... He was so generous that he fed all his friends, rich and poor, provided they were of some talent or worth."

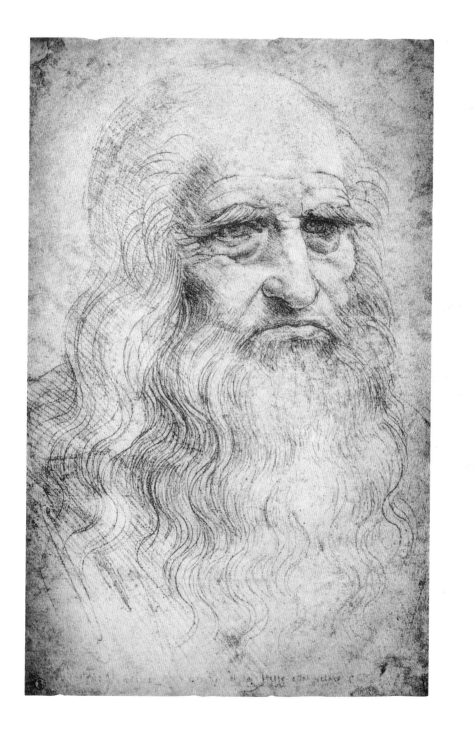

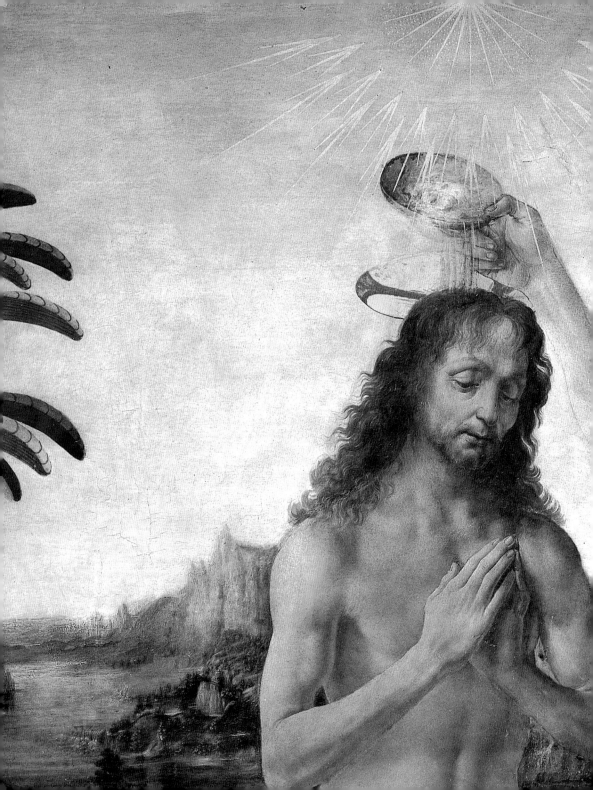

THE ARTIST AND THE MAN

Leonardo in Close-Up

"... a Saturday, at the 3rd hour of the night ..."

It was in his old notary's book, which later became a family chronicle, that his grandfather Antonio da Vinci recorded the birth of Leonardo da Vinci: "1452. There was born to me a grandson, the son of Ser Piero my son, on the 15th day of April, a Saturday, at the 3rd hour of the night [10.30 pm]. He bears the name Lionardo." The following day Leonardo was baptized in the small church of Santa Croce, in the company of several neighbors. However, his father and mother did not attend, and there were good reasons for this. It was Leonardo's grandfather Antonio who, in 1453, registered his birth in Florence, the entry stating: "Lionardo, son of the said Ser Piero, not legitimate, born of him and of Caterina, who is now the wife of Achattabriga di Piero del Vaccha da Vinci." His first grandson was therefore born illegitimate, the result of a relationship between his son Ser Piero and Caterina, a maid. Leonardo's young father, the notary (lawyer) Ser Piero, had moved from Florence to Vinci, and lived there for several years. He chose not to attend the baptism ceremony of his illegitimate son, particularly because during those months he was preparing for his marriage to Albiera di Giovanni Amadori, and did not wish to dwell on the consequences of his escapades of the previous summer.

In this delicate family affair, the wealthy Da Vinci family did what they could to help the young Caterina, and they looked for a man who would willingly accept a girl who was already a mother. A short while later, in 1453, she married a farmer from Campo Zeppi in Vinci by the name of Piero del Vaccha da Vinci, known as Achattabriga, who was most likely already a mercenary soldier like his brother Andrea.

The young Leonardo spent his childhood in the small house in Anchiano near Vinci, rarely seeing his mother and father, and spending most of his time with his grandfather Antonio, his grandmother Lucia, his uncle Francesco, and his stepmother Albiera di Giovanni Amadori, who died unexpectedly in 1464 without any children. Ser Piero then re-married Ser Giuliano Manfredini's daughter, the fifteen-year-old Francesca, who also died without children.

By the time of his third wedding in 1475, when he married Margherita di Francesco from Jacopo di Guglielmo, Ser Piero already had six children, to which six others were added during the course of his final marriage. At the age of forty-six Leonardo, already a fully-fledged artist, found himself with twelve step brothers and sisters who were much younger than he, and whom he scarcely knew, but who nonetheless gave him considerable trouble during the disputes over his father's inheritance.

Accusations of sodomy and sexual ambiguity

In April 1476 an anonymous denunciation was made to the city officials in Florence, accusing the seventeen-year-old Jacopo Saltarelli of engaging in sodomy: "To the officers of the Signoria: I hereby testify that Jacopo Saltarelli, the brother of Giovanni Saltarelli, lives with him at the goldsmith's shop in Vaccchereccia, directly opposite the *buco*; he dresses in black, and is seventeen years old or thereabouts. This Jacopo pursues many immoral activities and consents to satisfy those persons who request such sinful things, that is, he has provided such services to many dozens of persons of whom I have good information, and at the present time I name some of them. These men have sodomized the said Jacopo and so I will swear. Bartholomeo di Pasquino, goldsmith, living in Vacchereccia; Lionardo di Ser Piero da Vinci, said to live with

Andrea del Verrocchio; Baccino, the doublet-maker, living near Orsanmichele, in that street with the two large wool-shearers' shops leading down to the loggia of the Cierchi; he had opened a new doublet shop; Lionardo Tornabuoni, alias 'Il Teri', dressed in black." Those accused of sodomizing Jacopo therefore included the young Leonardo da Vinci, who was then working in Verrocchio's workshop. The severity of the accusation, albeit anonymous, if confirmed, meant castration for the adult sodomites and mutilation of a foot or a hand for the younger ones. Nevertheless, the investigations did not reach a formal conclusion, most likely because of the presence of a leading member of the Tornabuoni family, who were members of the Florentine aristocracy and related to the Medici family (Lorenzo de' Medici's mother was a Tornabuoni). His intervention would have proved crucial again when a similar complaint was lodged in June of the same year.

As well as offering a glimpse into the realities of fifteenth-century Florence, and providing reliable documentary evidence that Leonardo was still working in Verrocchio's workshop as late as 1476, this episode has fuelled speculation about Leonardo's supposed homosexuality. His frequent contact with his young apprentices, the close friendship he had with Francesco Melzi and Gian Giacomo Caprotti, known as Salaì, have given rise to a great deal of speculation on Leonardo's sexual identity and the impact this may have had on his art. Another of Vasari's anecdotes from Leonardo's childhood has proved particularly significant. According to Vasari, Leonardo once claimed that "the first recollection of my infancy, it seemed to me, was that while I was in my cradle a kite came to me and opened my mouth with its tail, and struck me several times with its tail inside my lips." For Sigmund Freud, who

devoted a long essay to Leonardo, such a recollection indicates a subconscious homosexuality.

"Therefore be curious to hear … the opinions of everyone on his work"

Even though Leonardo often preferred to live in the solitude of his own research and work, he was instinctively friendly and courteous. According to Matteo Bandello's account in his *Novella LVIII* (1497), one can easily imagine Leonardo experiencing a flash of inspiration whilst on the platform painting the *Last Supper*. In his novella he tells us that "many a time I have seen Leonardo go early in the morning to work on the platform before the *Last Supper*; and there he would stay from sunrise till darkness, never laying down the brush, but continuing to paint without eating or drinking. Then, three or four days would pass without his touching the work, yet each day he would spend several hours examining it and criticizing the figures to himself. I have also seen him, when the fancy took him, leave the Corte Vecchia when he was at work on the stupendous horse of clay [for the equestrian monument of Francesco Sforza], and go straight to the Grazie. There, climbing on the platform, he would take a brush and give a few touches to one of the figures; and then suddenly he would leave and go elsewhere."

Leonardo had no set routine or habits, and he lived unbothered by the constraints of time, always open to creativity and inspiration. His almost obsessive eye for detail and the endless modifications he made to his works (in particular to the *Mona Lisa*) were based on the conviction that (as he wrote to a young painter) "your work does not perish as soon as it is out of your hands, like the sound of music, but remains a standing monument of your igno-

rance. If you excuse yourself by saying that you have not time for the study necessary to form a great painter, having to struggle against necessity, you yourself are only to blame; for the study of what is excellent is food both for mind and body. How many philosophers, born to great riches, have given them away, that they might not be held back in their pursuits!" The same was true of excessive pandering to the views of others: "Therefore be curious to hear with patience the opinions of others," he wrote addressing the painter, "consider and weigh well whether those who find fault have grounds or not for blame, and, if so, amend; but if not, make as though you had not heard; or, if he should be a man you esteem, show him by argument the cause of his mistake."

Leonardo's relationship with Michelangelo

The relationship between Leonardo and Michelangelo, the two great masters of the Renaissance period, was a difficult one. This was mainly due to their contrasting temperaments and artistic ideals: the former was reflective, versatile, elegant, and a lover of nature, the latter notoriously quarrelsome, impulsive, and, as an adherent of a new and intense spirituality influenced by Neoplatonism, other-worldly.

In his treatise on painting, Leonardo would often condemn what he considered to be Michelangelo's anatomical excesses and overly muscular bodies as "sacks of walnuts," whilst avoiding directly mentioning him by name.

The unidentified author known as the Anonimo Gaddiano refers to discussions and heated arguments between both artists. In one of his accounts he relates an episode that took place by the Church of Santa Trinita in Florence: "Leonardo was walking with G[iovanni] di Gavine through [Piazza] Santa Trinita, and they passed the Pancaccia degli Spini where there was a gathering of citizens arguing over a passage of Dante; and they called out to the said Leonardo, asking him to explain the passage. At that point, by chance Michelangelo was passing by, and Leonardo answered their request by saying, 'There's Michelangelo, he'll explain it for you.' Upon which Michelangelo, thinking he had said this to insult him, retorted angrily, 'Explain it yourself—you who designed a horse to cast in bronze, and couldn't cast it, and abandoned it out of shame.' And so saying he turned his back on them and walked off. And Leonardo was left there, his face red because of these words: 'So those idiot Milanese actually believed in you!'"

Rivalry and misunderstanding still characterized their relationship during the first few months of the sixteenth century, when they were both commissioned to decorate the famous Salone dei Cinquecento (Hall of the Five Hundred) in the Palazzo Vecchio in Florence. This project never materialized, however. And when a committee met on 25 January 1504 to decide on the best position for the oversized statue *David*, Leonardo objected vociferously to its proposed position, claiming that the statue would seem overly dominant, an objection more suggestive of an aversion to the sculptor rather than the sculpture. Leonardo spoke up in front of the committee, which was made up of a large group of artists—including Sandro Botticelli, Andrea della Robbia, Simone Pollaiolo (known as Cronaca), Filippino Lippi, Pietro Perugino, Lorenzo di Credi, Cosimo Rosselli, and Giuliano and Antonio da Sangallo—and declared that: "I say that it should be placed in the Loggia as Giuliano has said, behind the low wall where the soldiers line up. It should be put there, with suitable ornaments, in such a way that it does not interfere with the ceremonies of state." His advice was not heeded,

however, and the majority decision was to place the statue in an eminent position, directly in front of the Palazzo Vecchio, which was the most important building in the city, much to Leonardo's chagrin.

Leonardo and portraiture

Amongst the many different fields of research and artistic development in which Leonardo was engaged, he laid great emphasis on portrait painting. The spontaneous, rapid sketches he made of particular facial features, expressions, and individual parts of the body were the fruits of a great deal of research into physiognomy and anatomy, and this contributed greatly to the sense of realism in his paintings. He filled many sketchbooks with drawings that seem rather disorganized, each face or feature sketched from many different angles. He was fascinated with the origin and cause of natural phenomena, and believed that art should be capable of portraying the essence of being. Leonardo developed an understanding of movement and proportion through the study of muscles, joints, and skeletons, which he then reproduced on paper. He even devised a method of recalling facial features: "If you want to acquire the facility for bearing in mind the expression of a face, first make yourself familiar with a variety of forms of several heads, eyes, noses, mouths, chins and cheeks and necks and shoulders. And to put a case: noses are of 10 types: straight, bulbous, hollow, prominent, above or below the middle, aquiline, regular, flat, round, or pointed. These hold good as to profile. In full face they are of 11 types: these are, equal thick in the middle, thin in the middle, with the tip thick and the root narrow, or narrow at the tip and wide at the root; with the nostrils wide or narrow, high or low, and the openings wide or hidden by the point. And you will find an equal variety in the other details; which things you must draw from nature and fix them in your mind. Or else, when you have to draw a face by heart, carry with you a little book in which you have noted such features; and when you have cast a glance at the face of the person you wish to draw, you can look, in private, which nose or mouth it is most like, or there make a little mark to recognize it again at home. Of grotesque faces I need say nothing, because they are kept in mind without difficulty."

Leonardo was ahead of his time with his drawing of a man (Biblioteca Reale, Turin) with a long beard in profile, then in three-quarters profile, and finally full face. His extraordinary ability to assimilate and portray physical features is demonstrated by his portrait of Lorenzo de' Medici, painted in Milan, on a page of the *Codex Atlanticus*.

Having grasped the laws of nature and physics, Leonardo turned his attention to the metaphysical, to the inner forces responsible for the continual external changes in the individual. In his treatise on painting, Leonardo explains his concept of *moti dell'animo* (motions of the soul): "The countenances of your figures should be expressive of their different situations: men at work, at rest, weeping, laughing, crying out in fear, or joy, and the like. The attitudes also, and all the limbs, ought to correspond with the sentiment expressed in the faces." It is therefore the "motions of the soul" that give detailed shape to the unique expression of the figure: each sentiment corresponds to a consequent external attitude and vice versa. In carefully defining this important correlation between the "motions" of the body and the soul, Leonardo also highlights the mistake made by those who replicate the same facial expressions, because they are never the same in nature. It can be said of Leonardo's portraits that

he does not achieve the meticulous and realistic rendering of anatomy that is found in his drawings and sketches; instead, he creates a holistic balance in which psychological truth is as important as anatomical detail.

This is certainly true of the *Lady with an Ermine*, *The Musician*, and the *Mona Lisa*. Every detailed element of the composition, from the face to the hands, from the landscape to the light, cleverly defines the internal world of the person portrayed in the painting. Every brushstroke, every touch of paint is designed to make us aware not only of what is miraculously right there before our eyes, but also of what is imperceptible.

Leonardo the scientist

It is thanks to Giorgio Vasari that we may learn about the characteristics of many famous artists, and read entertaining and sometimes strange anecdotes about them. He was a contemporary of many of these artists, which makes his accounts even more fascinating: "This marvelous and divine Leonardo was the son of Piero da Vinci. He would have made great profit in learning had he not been so capricious and fickle, for he began to learn many things and then gave them up. Thus in arithmetic, during the few months that he studied it, he made such progress that he frequently confounded his master by continually raising doubts and difficulties. He devoted some time to music, and soon learned to play the lyre, and, being filled with a lofty and delicate spirit, he could sing and improvise divinely with it."

From early childhood, the breadth and ever-changing character of Leonardo's curiosity must have perplexed his father Ser Piero and his grandfather Antonio. Leonardo was first and foremost a painter, sculptor, set designer, and architect; but he also devoted a great deal of time to philosophy, anatomy, optics, hydraulics, music, astronomy, geology, botany, mechanics, and cosmology. Leonardo pushed boundaries, driven by an insatiable desire to comprehend the laws of nature that regulate each and every animate and inanimate being on earth: trees, plants, stars, rivers, bones, muscles, plains, mountains, air, dust; moon and sun, shadow and light, life and death. Leonardo believed that all things, great and small, were controlled by a universal order: every phenomenon, trivial or otherwise, has a cause, a reason for being, and an innate character. Fired by his extraordinary curiosity, and seeing the world as powered by a kind of "engine," Leonardo dedicated himself, albeit in a chaotic fashion, to researching the nature of all phenomena. He wrote copious notes and made thousands of drawings and plans, scribbled in an impulsive and disorganized way over hundreds of sheets of paper. He read, studied and observed incessantly. He dissected over thirty corpses, invented incredible mechanical instruments, and made significant discoveries in the field of optics. He maintained that a good painter should study "in the dark, on first waking in the morning, and before going to sleep," commenting: "I myself have proved it to be of no small use, when in bed in the dark, to recall in fancy the external details of forms previously studied, or other noteworthy things conceived by subtle speculation; and this is certainly an admirable exercise, and useful for impressing things on the memory."

Vasari wrote of him: "And many were his whims, philosophizing on natural things, attempting to understand the properties of herbs, and constantly observing the motions of the sky, the course of the moon, and the behavior of the sun. For all of which he formulated in his soul a concept so heretical that is was far from any religion, reckoning

himself to be more a philosopher than a Christian." Leonardo was genuinely fascinated by "natural philosophy," and the practical application of his many discoveries, particularly in drawing, which he held to be not only a means of recording the world but also a reliable form of experimentation. The scope of his knowledge is well documented in his many manuscripts, and impressively depicted in both the form and content of his paintings.

Leonardo the inventor

Leonardo's mind was obsessed with the idea of nature, which he likened to a large, dark cavern before which he stood "stupefied and uncomprehending," watching with "fear and desire: fear for the menacing darkness of the cavern; and desire to ascertain if there were wonders therein." His painstaking observation of nature gave him the vast and accurate knowledge he needed to carry out his own experiments and inventions so tirelessly. These included many instruments for use in daily life, but mainly involved complex engineering works, military equipment, and imaginative means of transport, including an armored car, a bicycle, a helicopter, and a simple parachute ("if a man have a tent made of linen of which the apertures have all been stopped up, and it be 12 *braccia* [about 8 meters] across and 12 in depth, he will be able to throw himself down from any great height without suffering any injury").

Many of Leonardo's discoveries were made whilst studying the flight of birds, and he set himself the astonishing challenge of mastering the art of human flight, a subject that had held a life-long fascination for him. In the spring of 1505 he wrote the basis of what was to become his *Treatise on the Flights of Birds*, and three years later conducted his own anatomical studies of birds' wings and

the nature of air resistance. By 1515 he was studying the motion of air and describing the effects of a falling weight. All this culminated in the invention of his first flying machine, to which a particular biographical note seems to refer: "The first flight of the great bird from the summit of Monte Ceceri will fill the universe with wonder; all writings will be full of its fame, bringing eternal glory to the place of its origin." Legend has it that Leonardo tested out its first flight from the hill near Fiesole, not piloted by him personally but by his close friend Tommaso Masini, known as Zoroastro. However, the flight did not prove successful—it seems that his friend fell to earth and broke a leg.

The "Feast of Paradise" and other extravaganzas

On 13 January 1490, in the Castello Sforzesco in Milan, the curtain went up on Leonardo's complex and highly inventive stage set for the "Feast of Paradise" (La Festa del Paradiso) by the poet Bernardo Bellicioni, performed in honor of the wedding of Gian Galeazzo Sforza and Isabella of Aragon. In the prologue to Bellincioni's poem, published three years later, he congratulates Leonardo not only as an excellent painter, "a new Appelles," but also as a skilful theater designer: " It was called 'Il Paradiso' because Maestro Leonardo da Vinci, the Florentine, had with great art and ingenuity fabricated a paradise or celestial sphere, in which the seven planets were represented by actors in costumes similar to those described by the poets of old, who each in turn spoke in praise of Duchess Isabella."

A document written shortly after the event, now preserved in the Estense Library in Modena, describes the ornate sets, the reaction of the public, the actors who took

part, and the opulence of the costumes: "Il Paradiso was made in the shape of an egg, which on the inner part was all covered with gold, with a very great number of lights, as many as stars, and within certain niches [fessi] there stood all the seven planets according to their degree, high and low. Around the top edge of this hemisphere were the twelve signs [of the Zodiac], with certain lights behind glass, which made a gallant and beautiful spectacle. In this Paradiso were heard many songs and many sweet and graceful sounds."

It was a resounding success for Leonardo, as were the costumes and sets for Baldassarre Taccone's comedy *Danae*, which was performed at the house of Count di Cajazzo in Milan on 31 January 1496. The designs for the stage set can be found among the drawings in one of Leonardo's notebooks, now housed in the Metropolitan Museum in New York. There is a preparatory study for the stage set: a fiery character (perhaps Jupiter) is shown centre stage, next to an almond tree, and the stage seems to be in the shape of a tree, with curved wings reserved for the musicians. Other sources describe gods appearing from above, remaining suspended in the air amongst the stars; startling lighting effects; and a mobile, complex stage structure made up of hoists and other mechanisms that allowed performers to appear and disappear with ease. These automated systems were similar to the more famous designs that appear amongst the pages of the Codex Arundel. Leonardo's creative genius pushed him beyond the realization of daring theatrical structures to the development of mobile structures. One such example is his famous mechanical lion, which appeared in Lyon and in Florence in 1515 and two years later in Argenton, for the coronation of Francis I: "Once in front of Francis I, King of France, [Leonardo] made a lion, constructed with amazing skill, walk to his place in a hall and then, stopping, opened its chest, which was filled with lilies and various flowers" (Giovanni Paolo Lomazzo).

Final days: "because the soup is getting cold"

On 23 April 1519, just before his death, a weak and feeble Leonardo summoned the French royal notary Guillame Boureau and drew up his will in the presence of five witnesses and his inseparable friend Francesco Melzi. In his will, Leonardo also gave instructions for his own burial in the church of Saint Florentin at Amboise: his body was to be carried by chaplains and young monks and accompanied by sixty poor men each carrying a torch. Three High Masses were to be said by a deacon and a sub-deacon, and thirty Low Masses of St. Gregory, and these Masses were to be said at the church of Saint Denis and in the Franciscan church. Melzi was to be the beneficiary of the majority of Leonard's impressive collection of volumes, paintings, instruments from the workshop, and clothes. Various other items were to be shared among those who had stood by him during his life: Francis I, Salaì, and his servant Batista. His stepbrothers were to receive the money deposited in the Hospital of Santa Maria Nuova in Florence, which amounted to more than four hundred *scudi*.

Leonardo died a few days later, on 2 May. Francis I was in Saint-Germain-en-Laye at the time, and was inconsolable when Melzi told him that the master had passed away. The last entry that exists on an autographic manuscript is dated June of the previous year. At that time, Leonardo was working in his room on various dissertations on geometry. It must have been getting late, but he was still engrossed in a complex thread of reasoning, as

often happened. The calculations, examples, and conclusions were becoming increasingly complicated. It seemed that he needed more time, but someone must have been calling him; distracted and annoyed, at first he pretended not to hear anything. Then, vexed, he wrote on the page, "etcetera, because the soup is getting cold"! It is incredible to think that this spontaneous, exasperated comment should be one of the last records we have of Leonardo. We feel an affinity with him through this very human annoyance. It is such everyday, seemingly inconsequential aspects of his life that brings this distant, magisterial figure closer to us. Likewise, the poet Petrarch interrupted himself mid-flow with the comment *quia vocor ad cenam* ("because I am called to dinner"). Such unassuming comments make the great characters of history more human; ultimately they are mere mortals like the rest of us, with basic human needs, feelings, and reactions.

Leonardo's *Treatise on Painting*

The day after Leonardo passed away, his close friend Francesco Melzi left Amboise and went to live on the family estate in Vaprio d'Adda. He inherited mainly books, manuscripts, and instruments from Leonardo's workshop, which according to comments by Anonimo Gaddiano (1537–1542), Giorgio Vasari (1568), and Giovanni Paolo Lomazzo (1590) he seems to have guarded jealously. There is every probability that these documents constituted only a part of Leonardo's heritage: Vasari's account relates that "a painter of Milan" (possibly Aurelio Luini), had in his possession "certain writings of Leonardo likewise in characters written with the left hand, backward, which treat of painting, and of the methods of drawing and coloring." It is easy to imagine how quickly this large collection of books

and loose papers belonging to Leonardo would have become disseminated. They included more than one hundred books that he owned, ranging from Aristotle to Dante, from Galen to Petrarch, and around fifty books he had written himself—twenty-five "small books," sixteen "books even larger," two "books of larger size," six "books on vellum" and one "bound in green chamois."

It is not known for sure whether it was Melzi, or Vasari's mysterious Milanese painter, who signed the documents by Leonardo that an auditor then proceeded to copy into a volume belonging to the court of Urbino, which became known as the Urbinate (*Codex Urbinas Latinus 1270*) or simply as the *Treatise on Painting*. In 1509 Leonardo had mentioned to the mathematician Luca Pacioli that he had been working on a treatise on "movement," and had already completed one on "painting and human movements," though both have disappeared without trace.

The Treatise on Painting is, as we know today, a posthumous collection of writings compiled by his students, who selected various passages of Leonardo's notes from a total of eighteen notebooks, only seven of which exist today. Nevertheless, it seems likely that Leonardo had wanted to divide the treatise into two parts. The first was to be theoretical, expounding the philosophical principles of painting and the other arts, and describing the principles of perspective (linear, aerial, and chromatic) and of light and shadows. The second section was to be practical, containing Leonardo's suggested course of study for young painters (which were far removed from the didactic methods dictated by Cennino Cennini's earlier treatise), the ways of determining the proportions of the body, and the methods of gaining an understanding of natural phenomena. However, the main theme of the treatise concerns what Leonardo termed "the philosophy of knowing

how to see"—a concept that, underpinning all his studies, had inspired him from his earliest days in Verrocchio's workshop. He believed that every aspect of painting must be connected to a systematic understanding of natural phenomena, and therefore of physics, mathematics, and geometry. It was due to his excellence in these spheres that Leonardo was able to sustain the "scientific" aspects of his paintings, thereby giving them equal status with the other liberal arts, such as philosophy, poetry, and theology. He realized that painting is a truly universal language, for the visual language is common to all peoples, unlike the written word, which has to be translated into different languages.

The Last Supper

Leonardo's famous *Last Supper* in the refectory of the convent of Santa Maria delle Grazie in Milan underwent a long period of restoration from 1978 to 1999, and during this time the art historians, restorers, and technicians working on the painting tried to establish which parts constituted authentic work actually executed by Leonardo. The painting was in a dilapidated state, having over the centuries been subjected to alteration and restoration, as well as to vandalism by Napoleon's troops and the tragic bombing of the summer of 1943. The *Last Supper*'s poor state of preservation was also due to the unfortunate choice of technique used by Leonardo, which only a few years after it was completed caused Vasari to declare that there was nothing left of the painting apart from "a muddle of blots." Various measures were taken in an attempt to clarify the blurred outlines and to prevent further deterioration due to the humid conditions: the application of a thick layer of glue, resin, solvents, and varnishes added in a piecemeal

fashion over the years notably worsened the condition of the delicate painting. By the late 1970s the situation seemed hopeless, but thanks to a meticulous and rigorous restoration this great masterpiece was able to be viewed by the public again and saved for posterity.

In addition to establishing which elements were actually painted by Leonardo, the restoration project also uncovered interesting aspects of the techniques he used to create the complex pictorial scene. The reflective nature of the subject matter led Leonardo to abandon the traditional fresco technique, which requires a painter to work quickly, and opted instead for a method in which the paint dried more slowly, allowing the countless alterations and afterthoughts typical of his working method. At the beginning of the sixteenth century, in the Salone dei Cinquecento (Chamber of the Five Hundred) in the Palazzo Vecchio in Florence, he would once again experiment with an encaustic technique (employing wax paints) that was more suited to his own needs, but again the results were very disappointing. (It is said that he misinterpreted Pliny the Elder's recipe.) For the *Last Supper* he decided to abandon the fresco technique because of the rigid timeframe required in which to complete the painting process. Instead, he applied an expanse of rough plaster in the central panel, onto which he drew the outline of the composition, the *sinopia*. He then adopted a preparatory technique derived directly from painting on wood, using a mixture of calcium carbonate and magnesium carbonate with a protein binder to create a ground. Before he used the paints, he added a coating of white lead, a process that, absolutely unheard of in fresco painting, was intended to give greater luminosity to the paint. Finally, once the plaster dried, he applied the paint, with an almost infinite number of tiny brushstrokes, subtly layering the colors.

Codes, mysteries, and conspiracies

Aspects of Leonardo's life have always been shrouded in mystery—his eccentricity, for example, his secretive private life, and his wide diversity of interests, ranging from art to mathematics, anatomy to botany, and mechanics to geology. These interests generated most of his research, which has been the subject of admiration, but also of some puzzlement, particularly regarding his secretive anatomical investigations, and his inherently covert experimental approach. Another mysterious factor of his working methods was his cryptic writing: in addition to writing left-handed, from right to left, he would often write sentences in code or simply in the form of anagrams and rebuses.

It is therefore no surprise that the character of such a complex and extraordinary individual has been the subject of distortion, misinterpretation, and exploitation. The huge commercial success *The Da Vinci Code*, by Dan Brown, is a case in point. This novel, which intertwines history, esotericism, theology, unresolved suicides, and clever cliff-hangers, is based on the supposed discovery of a secret that would be devastating for the history of Christianity: Christ is said to have married Mary Magdalene, and their offspring and descendants then became the secret members of the Priory of Sion, which came into conflict with the established ecclesiastical hierarchy, and with the sect Opus Dei. In an intricate continuum of events based on fact and fiction, it has been alleged that Leonardo himself was a Grand Master of the Priory of Sion, and that in some of his works he had suppressed evidence that could have attested to his active participation. Two such examples would be the *Mona Lisa* and the *Last Supper*. According to Dan Brown, the famous painting in the Louvre is not a portrait of Mona Lisa, but a self-portrait of the painter (hence the enigmatic smile); and the androgynous apostle seated to the right of Christ in the *Last Supper* is actually Mary Magdalene, not St. John.

Despite the huge controversy surrounding his well-argued historical and artistic reconstructions, it must be conceded that his book has also generated a genuine and almost obsessive interest in everything to do with Leonardo da Vinci. There have been numerous exhibitions and documentaries about him the world over, rekindling further research on all aspects of his work, which is at least one positive outcome of the book, whatever one's opinion of it.

Leonardo's need for solitude

"If you are alone you belong entirely to yourself. If you are accompanied by even one companion you belong only half to yourself, or even less, in proportion to the thoughtlessness of his conduct; and if you have more than one companion you will fall more deeply into the same plight." Leonardo's continual observation of the world, down to the minutest of details, was a fascinating but demanding process.

His mind was so active that he had no time for distractions and ended up living a life of intellectual solitude, a "vocation" that certainly had an impact on his personal life. He would never allow his mind to stop observing, pondering, imagining. Although he would seek company when he needed it, most of his "conversations" took the form of imaginary dialogues. Leonardo remained obstinate in the face of the "sect of hypocrites" who criticized him for continuing to produce drawings and studies on Sundays, or during religious festivals. It seems that his mind even remained active during the night: "I myself have proved it to be of no small use, when in bed in the dark, to recall

in fancy the external details of forms previously studied, or other noteworthy things conceived by subtle speculation; and this is certainly an admirable exercise, and useful for impressing things on the memory."

For Leonardo, a prolific author of riddles, jokes, puzzles, and rebuses, even games were never just for fun; for him they constituted yet another means of gaining knowledge. An innocent pastime such as blowing soap bubbles or skimming stones could illustrate some aspect of the laws of physics. For Leonardo, a simple walk would entail a continual mental barrage of ideas and observations, and the scope of his imagination was boundless. "If you sometimes take the time to pause and look at such things as stains on walls, ashes from the fire, clouds or mud, you can find yourself immersed in the most beautiful of inventions."

Yet it took time to process and assimilate all these observations, and so even when Leonardo was painting he would alternate full days of work with periods of inexplicable, apparent inactivity, which irritated his clients. According to Vasari, Leonardo's response was to say: "Men of genius may be working when they seem to be doing the least."

Leonardo's equestrian project

The most prestigious commission that Ludovico Sforza entrusted to Leonardo was undoubtedly the creation of the equestrian statue of his father, Francesco Sforza. In his introductory letter to Ludovico, Leonardo had stressed that he was able to work with bronze, marble, and clay, all skills he undoubtedly learnt during his time in Andrea del Verrocchio's workshop. Scholars have often speculated about the young pupil's direct involvement in some of the sculptures produced in the Florentine workshop, including the sophisticated portrait bust of the *Lady with Flowers*, now in the Bargello, which is attributed to Verrocchio.

We know that Leonardo did begin work on the challenging design of the bronze statue. He visited the stables belonging to Ludovico and other dignitaries in order to study the anatomy and movement of the horses, even mentioning some of them by name in his notes. We know that Leonardo's workshop had all the materials needed for the project, but that Leonardo's proverbial "apathy" began to make Ludovico uneasy. He started to doubt that the project would ever be completed, and in 1489 his secretary wrote to Lorenzo de' Medici asking him to send sculptors capable of completing the work: "Signor

Ludovico wishes to raise a noble memorial to his father, and has already charged Leonardo da Vinci to prepare a model for a great bronze horse, with a figure of Duke Francesco in armor. But since His Excellency is anxious to have something superlatively fine, he desires me to write and beg you to send him another master, for although he has given the work to Leonardo, he does not feel satisfied that he is equal to the task." Leonardo's initial idea had been to create a full-size sculpture of a rearing horse, but then he changed his mind, and set himself the task of designing a colossal sculpture up to four times life-size. A statue of these dimensions meant that the horse would have to be shown trotting (so that the weight was more evenly distributed), and by the May of 1491 he had successfully prepared the clay model that measured 12 *braccia* ("the said height from the nape to the flat ground" [around seven meters high]). But the change in the Italian political climate caused Ludovico to appropriate all the metal set aside for the statue, forcing Leonardo to abandon the project. After the French invasion, the Sforza family left the city in 1499 and Leonardo escaped to Mantua and then Venice. In the end, the clay model was abandoned in the castle and ended up being destroyed by French troops, who used it for target practice.

Anthology

The painter is lord of all types of people and things. If he wishes to see beauties that charm him it lies in his power to create them, and if he wishes to see monsters that are terrifying, clownish, absurd or pitiful, he can be the lord and god of them; if he wants to produce inhabited regions or deserts, or dark and shady retreats from the heat, or warm places in cold weather, he can do so. If he wants valleys, if he wants vast plains to unfold from high mountain tops down to the sea's horizon, he is lord to do so. ... In fact, whatever exists in the universe, in essence, in appearance, in imagination, the painter has first in his mind and then in his hand; and these are of such excellence that they can present a proportioned and harmonious view of the whole, that can be seen ... at a glance, just as in nature.

He who despises painting loves neither philosophy nor nature. Those who despise painting, which is the only imitator of the visible works of nature, despise a subtle invention that brings philosophy and subtle speculation to bear on the nature of all forms—sea and land, plants and animals, grasses and flowers ...

Leonardo da Vinci

The distinguished works which Master Leonardo da Vinci, your fellow Florentine, has left behind in Italy, and in particular in this city [Milan], dispose all who see them to hold him in particular affection, even if they have never met him. And we must confess that we, too, number amongst those who held him dear even before we met him in person. Having had dealings with him and having experienced his talents [*virtute*] for ourselves, however, we saw truly that his name, made famous through painting, still shines less brightly than it deserves in view of his other talents. And we must admit that in the things he produced as examples at our request, in drawing and architecture and other areas pertinent to our requirements, he satisfied us in a way which not merely matched our expectations but filled us with admiration.

Charles d'Amboise
Letter from Milan, 1506

Due to the fact that Leonardo was constantly striving to learn new and sophisticated artistic techniques, frequently discarding his initial ideas on a whim or through impatience, very few of his works were ever completed. Greatly admired in Milan, nevertheless, is a wall-painting of Christ dining with his disciples. King Louis of France is said to have been so taken with this work that, contemplating it with profound emotion, he asked those around him whether it was possible to remove it from the wall and take it back to France, even if it meant destroying the famous refectory. There remains an oil painting by Leonardo depicting the infant Jesus playing with his mother and St. Anne, which Francis, the King of France purchased for his chapel, also the scene of the victorious battle of Pisa in the Sala del Consiglio of the Florentine Signoria; a magnificent work but left unfinished due to either faulty nut oil or a defect in the plaster which rejected the pigments. But the upset caused by the unexpected damage appears to have generated more interest in his unfinished work.

He also fashioned a colossal horse in clay for Ludovico Sforza, which he then used as a basis for one similar in bronze, surmounted by the figure of his father Francesco, distinguished leader. In the impetuous and eager figure of the animal, Leonardo demonstrated his skill both as a sculptor and as an observer of nature.

Paolo Giovio
Leonardi Vincii vita, 1523–1527

His genius was so rare and universal that it can be said that nature worked a miracle on his behalf: not only in the beauty of his person, but in the many gifts with which she endowed him and which he fully mastered.

He was a talented mathematician and painter in perspective, but his works as a sculptor and designer surpassed all others. He was responsible for many beautiful inventions, but most of his major works of art were never completed because he was never satisfied with what he did.

Leonardo was eloquent in speaking and a gifted player of the lyre and he was the master of Atalante Migliorotti. Although he was drawn to the simple things in life, his consummate skills and his restless mind meant that he was a continual innovator and inventor.

Anonimo Gaddiano
Libro sugli artisti, 1537–1542

Leonardo undertook to execute, for Francesco del Giocondo, the portrait of Mona Lisa, his wife; and after toiling over it for four years, he left it unfinished; and the work is now in the collection of King Francis of France, at Fontainebleau. In this head, whoever wished to see how closely art could imitate nature was able to comprehend it with ease; for in it were counterfeited all the minuteness that with subtlety is able to be painted, seeing that the eyes had that lustre and watery sheen which are always seen in life, and around them were all those rosy and pearly tints, as well as the lashes, which cannot be represented without the greatest subtlety. The eyebrows, through his having shown the manner in which the hairs spring from the flesh, here more close and here more scanty, and curve according to the pores of the skin, could not be more natural. The nose, with its beautiful nostrils, rosy and tender, appeared to be alive. The mouth, with its opening, and with its ends united by the red of the lips to the flesh tints of the face, seemed, in truth, to be not colours but flesh. In the pit of the throat, if one gazed upon it intently, could be seen the beating of the pulse. And, indeed, it may be said that it was painted in such a manner as to make every valiant craftsman, be he who he may, tremble and lose heart. He made use, also, of this device: Mona Lisa being very beautiful, he always employed, while he was painting her portrait, persons to play or sing, and jesters, who might make her remain merry, in order to take away that melancholy which painters are often wont to give to the portraits that they paint. And in this work of Leonardo's there was a smile so pleasing, that it was a thing more divine than human to behold; and it was held to be something marvellous, since the reality was not more alive.

Giorgio Vasari
The Lives of the Most Excellent Italian Painters, 1568

Leonardo Vinci is worth remembering as he taught the anatomy of the human body ... which I have seen at Francesco Melzi's, drawn divinely by Leonardo's hand ... but of all these works none was printed, existing only in his manuscripts which in great part have come into the hands of Pompeo Leoni ... and some also came into the hands of Signor Guido Mazenta, distinguished scholar who treasures them lovingly.

Giovanni Paolo Lomazzo
Idea del tempio della pittura, 1584

[on the *Mona Lisa*] The presence that rose thus so strangely beside the waters, is expressive of what in the ways of a thousand years men had come to desire. Hers is the head upon which all "the ends of the world are come," and the eyelids are a little weary. It is a beauty wrought out from within upon the flesh, the deposit, little cell by cell, of strange thoughts and fantastic reveries and exquisite passions. Set it for a moment beside one of those white Greek goddesses or beautiful women of antiquity, and how would they be troubled by this beauty, into which the soul with all its maladies has passed! All the thoughts and experience of the world have etched and moulded there, in that which they have of power to refine and make expressive the outward form, the animalism of Greece, the lust of Rome, the mysticism of the middle age with its spiritual ambition and imaginative loves, the return of the Pagan world, the sins of the Borgias. She is older than the rocks among which she sits; like the vampire, she has been dead many times, and learned the secrets of the grave; and has been a diver in deep seas, and keeps their fallen day about her; and trafficked for strange webs with Eastern merchants: and, as Leda, was the mother of Helen of Troy, and, as Saint Anne, the mother of Mary; and all this has been to her but as the sound of lyres and flutes, and lives only in the delicacy with which it has moulded

the changing lineaments, and tinged the eyelids and the hands. The fancy of a perpetual life, sweeping together ten thousand experiences, is an old one; and modern philosophy has conceived the idea of humanity as wrought upon by, and summing up in itself all modes of thought and life. Certainly Lady Lisa might stand as the embodiment of the old fancy, the symbol of the modern idea.

Walter Pater
The Renaissance, 1893

And just as his art is life-communicating as is that of scarcely another, so the contemplation of his personality is life-enhancing as that of scarcely any other man. Think that great though he was as a painter, he was no less renowned as a sculptor and architect, musician and improviser, and that all artistic occupations whatsoever were in his career but moments snatched from the pursuit of theoretical and practical knowledge. It would seem as if there were scarcely a field of modern science but he either foresaw it in vision, or clearly anticipated it, scarcely a realm of fruitful speculation of which he was not a freeman; and as if there were hardly a form of human energy which he did not manifest. And all that he demanded of life was the chance to be useful! Surely, such a man brings us the gladdest of all tidings—the wonderful possibilities of the human family, of whose chances we all partake. Painting, then, was to Leonardo so little of a preoccupation that we must regard it as merely a mode of expression used at moments by a man of universal genius, who recurred to it only when he had no more absorbing occupation, and only when it could express what nothing else could, the highest spiritual through the highest material significance. And great though his mastery over his craft, his feeling for significance was so much greater that it caused him to linger long over his pictures, labouring to render the significance he felt but which his hand could not reproduce, so that he rarely finished them. We thus have lost in quantity, but have we lost in quality? Could a mere painter, or even a mere artist, have seen and felt as Leonardo? We may well doubt. We are too apt to regard a universal genius as a number of ordinary brains somehow conjoined in one skull, and not always on the most neighbourly terms. We forget that genius means mental energy, and that a Leonardo, for the self-same reason that

prevents his being merely a painter—the fact that it does not exhaust a hundredth part of his energy—will, when he does turn to painting, bring to bear a power of seeing, feeling, and rendering, as utterly above that of the ordinary painter as the *Mona Lisa* is above, let us say, Andrea del Sarto's *Portrait of his Wife*. No, let us not join in the reproaches made to Leonardo for having painted so little; because he had much more to do than to paint, he has left all of us heirs to one or two of the supremest works of art ever created.

Bernard Berenson
The Italian Painters of the Renaissance, 1897

He discovered the painterly charm of the surfaces of things and yet he can think as a physicist and an anatomist. Qualities which seem mutually exclusive are combined in him the tireless observation and collection of data of the scientist, and the most subtle artistic perception. As a painter, he is never content to accept things merely by their outward appearance: he throws himself into investigating, with the same passionate interest, inner structure and the factors governing the life of every created thing. He was the first artist to make a systematic study of proportion in men and animals and to investigate the mechanics of movements like walking, lifting, climbing, pulling, and it was he, too, who made the most comprehensive physiognomic studies and thought out a coherent system for the expression of emotions.

For him, the painter is like a clear eye which surveys the world and takes all visible things for its domain. Suddenly the world revealed itself in all its inexhaustible riches and Leonardo seems to have felt himself united by a great love to all living things. Vasari tells a story which reveals this: he was sometimes seen in the market-place, buying caged birds that he might give them back their freedom. This incident seems to have impressed the Florentines.

In so universal an art there are no major or minor problems; the ultimate subtleties of light and shade are not more interesting than the most elementary task—the rendering of a three-dimensional object in apparent solidity on a flat surface—and the artist who, more than any other, made the human face a mirror of the soul can, still say, "Relief is the principal aim and the soul of painting." Leonardo was so sensitive to so many more aspects of

things that he was forced to seek new technical methods. He became an experimenter who could scarcely satisfy himself. He is said to have allowed the *Mona Lisa* to leave his studio before he considered it to be finished. Technically, she is a mystery, but even where the medium is obvious, as in the simple silver-point drawings, he is no less astounding. He is perhaps the first to use line with expressive sensibility and there are almost no parallels for the way in which his contours are made up of touches of varying firmness. He models with simple, parallel, even strokes; it is as if he needed only to stroke the surface to bring out the roundness of the form. Never have simpler means been used to greater effect, and the parallel lines, like those which occur in older Italian engravings, give an inestimable unity of effect to the drawings.

We have but few completed works by Leonardo. He was untiring in observation and insatiable in his search for knowledge, he continually set himself fresh problems, yet it seems as if he wished to solve them only for himself. He could never bring himself to a definite conclusion or to finish off a picture, and the problems which he set himself were so far-reaching that he may well have felt that his solutions were only provisional.

Heinrich Wölfflin
Die Klassische Kunst, 1898. English translation: Classic Art, 1952

Many people have attacked the *Gioconda*, notably in lapidating her some years ago, the very type of flagrant case of aggression against one's own mother. Knowing all Freud thought about Leonardo da Vinci, all that the latter's art kept hidden in his subconscious, it is easy to deduce that he was in love with his mother when he painted the *Gioconda*. Without realizing it, he painted someone who has all the sublimated maternal attributes. She has big breasts, and she looks upon those who contemplate her in a wholly maternal way. At the same time, she smiles in an equivocal manner. Everybody has seen, and can still see today, that there was a very determinant element of eroticism in that equivocal smile. So, what happens to the poor wretch who is possessed by an Oedipus complex, that is, the complex of being in love with his mother? He goes into a museum. A museum is a public house. In his subconscious it is a brothel. And in this brothel he sees the representation of the prototype of the image of every mother. The agonizing presence of his mother gives him a tender look and an equivocal smile and drives him to a criminal act. He commits matricide by picking up the first thing that comes to hand, a stone, and destroying the painting. It is a typical paranoiac aggression.

Salvador Dalí
Diario de un genio, 1964. English translation: Diary of a Genius, 1965

Locations

AUSTRIA
Vienna
Albertina
*Study of the Figure of St. Peter for the
Last Supper*, c. 1488–1490

BRITAIN
Edinburgh
National Gallery of Scotland
Madonna of the Yarn Winder, c. 1501
London
British Museum
Bust of a Warrior in Profile, 1475–
1480
Military Machines, c. 1487
Abdomen and Leg of a Man, 1506–
1507
National Gallery
The Virgin of the Rocks, 1494–1508
*The Virgin and Child with St. Anne and
St. John the Baptist (Burlington
House Cartoon)*, c. 1499–1500
Windsor
Royal Library
Cross-Section of a Skull, c. 1489
Marsh Blueberry, c. 1506

FRANCE
Bayonne
Musée Bonnat
*Study of a Hanged Man (Bernardo
Baroncelli)*, 1478

Paris
Bibliothèque de l'Institut de France
Aerial Screw, c. 1487
*Rays of Light Through an Angular
Opening*, 1490–1491
*Geometrical Figures and Botanical
Drawings*, c. 1490
Emblem of the Sforza, 1493–1494
Musée du Louvre
The Annunciation, 1478–1480
The Virgin of the Rocks, 1483–1486
La Belle Ferronière, c. 1490–1495
Isabella d'Este, c. 1500
Mona Lisa (La Gioconda), 1503–1514
St. John the Baptist, 1508–1513
Virgin and Child with St. Anne,
c. 1510–1513
*Bacchus (Formerly St. John the
Baptist)*, 1510–1515

GERMANY
Munich
Alte Pinakothek
Madonna of the Carnation, c. 1473

HUNGARY
Budapest
Szépmüvészeti Museum
*Study of the Head of a Warrior for The
Battle of Anghiari*, c. 1504

ITALY
Florence
Gabinetto Disegni e Stampe,
Galleria degli Uffizi
*Landscape of the Arno Valley
(Landscape with River)*, 1473
*Perspective Study for the Adoration
of the Magi*, c. 1481
Sketch of Three Figures in Profile,
c. 1495
Galleria degli Uffizi
Annunciation, c. 1472–1475
The Baptism of Christ, 1475–1478
The Adoration of the Magi, 1481–
1482
Milan
Biblioteca Ambrosiana
Studies of Defensive Equipment,
c. 1480
Studies of Hydraulic Instruments,
c. 1480
*Designs of a Cross for Milan
Cathedral*, 1487–1488
Sketch of a Lady's Purse, 1497
Design for a Bastion, 1502–1503
Stronghold in the Shape of a Polygon,
c. 1502–1503
*Canal for Navigation Between the
Lake of Lecco and the Lambro*,
c. 1513
Studies of Geometry, c. 1513
Studies for the Civitavecchia, c. 1514
Biblioteca Trivulziana
Facing Figures, Young and Old,
c. 1495

Civiche Raccolte d'Arte, Castello Sforzesco
 Interlacing Branches, c. 1498
 Head of Leda, c. 1510
Pinacoteca Ambrosiana
 The Musician, c. 1485
Pinacoteca di Brera
 Head of Christ, c. 1494
Refectory of Santa Maria delle Grazie
 The Last Supper, 1495–1498
 Portraits of the Duke and Duchess of Milan with Their Sons, 1497
Parma
Galleria Nazionale
 Head of a Young Woman (La Scapigliata), c. 1508
Rome
Pinacoteca Vaticana
 St. Jerome, c. 1480
Turin
Biblioteca Reale
 Possible Study for the Angel in The Virgin of the Rocks, 1483–1485
 Study of War Machines, 1487–1490
 Study of the Forelegs of a Horse, c. 1490
 Study of a Male Head, 1494 or 1499
 Self-Portrait, c. 1515
Venice
Gallerie dell'Accademia
 Study of Flowers, 1480–1481
 Vitruvian Man (Man in a Circle), c. 1490

Study of Proportions for the Battle of Anghiari: Infantrymen and Cavalrymen, 1503–1504
Study of Three Dancing Figures, c. 1515

POLAND
Cracow
Czartoryski Museum
 Lady with an Ermine, 1488–1490

RUSSIA
St. Petersburg
Hermitage Museum
 Madonna and Child (Benois Madonna), 1478–1482

SPAIN
Madrid
Biblioteca Nacional de España
 Framework with Casting Mold in the Shape of a Horse's Head, 1491–1493
 Design of a Device, 1494–1496

UNITED STATES
New York
Private collection
 Madonna and Child (Madonna of the Yarn Winder), c. 1501
Washington
National Gallery of Art
 Ginevra de' Benci, c. 1474
 Madonna and Child with a Pomegranate (Dreyfus Madonna), c. 1469

Chronology

The following is a brief overview of the main events in the artist's life, plus the main historical events of the day (in italic).

1452
15 April: Leonardo da Vinci is born in Anchiano near Vinci, the illegitimate son of the notary Ser Piero di Antonio and peasant girl Caterina.
In Rome Frederick III is crowned Holy Roman Emperor. Ghiberti completes the Gates of Paradise in Florence; Piero della Francesca starts the frescoes in the church of San Francesco in Arezzo.

1469
Moves to Florence, and it is likely that he begins working in Andrea del Verrocchio's workshop.
Piero de' Medici dies in Florence, and is succeeded by Lorenzo de' Medici (Lorenzo the Magnificent). Niccolò Machiavelli is born.

1472
Becomes a member of the artists' guild (*Compagnia di San Luca*), and becomes an independent artist (master). Starts to work on the *Annunciation*.
Leon Battista Alberti dies. Federico da Montefeltro sacks Volterra.

1473
Creates *Landscape of the Arno Valley*, dated 5 August.

1475
6 March: Michelangelo Buonarroti is born in Caprese.

1476
9 April: Among others, is accused of sodomy, later acquitted. Still in Verrocchio's workshop.
Galeazzo Maria Sforza is assassinated in a conspiracy in Milan. His son Gian Galeazzo succeeds him.

1478
Paints two Madonnas, one of which has been identified as the *Madonna and Child (Benois Madonna)*.
Despite the death of Giuliano de' Medici, the Pazzi Conspiracy fails in Florence and Lorenzo de' Medici's power is consolidated.
Giorgione is born.

1481
Commissioned by the monks of San Donato in Scopeto to paint the *Adoration of the Magi*.
In Rome, Pope Sixtus IV commissions Botticelli, Rosselli, Ghirlandaio, Pinturicchio, and Perugino to paint the walls of the Sistine Chapel.

1482
Leaves Florence and travels to Milan, sent by Lorenzo de' Medici to present the Duke Ludovico Sforza with a silver lyre.

Botticelli starts working on his Primavera. Flemish artists Hugo van der Goes dies.

1483
Together with the De Predis brothers, receives the commission that results in the *Virgin of the Rocks*.
Raphael is born in Urbino. Botticelli paints his Birth of Venus.

1487
Receives payment for his designs for the dome for Milan Cathedral.
Giovanni Bellini paints the San Giobbe Altarpiece.

1489
Begins the design of the equestrian statue of Francesco Sforza; designs the decorations for the wedding of Isabella of Aragon and Gian Galeazzo Sforza.

1491
The young Gian Giacomo Caprotti, known as Salaì, becomes Leonardo's pupil.

1494
Starts work on the *Last Supper*, painted on the wall of the refectory in the convent of Santa Maria delle Grazie in Milan.
The Medici are driven out of Florence, and the Republic is established.

1498
Completes the decoration in the Sala delle Asse in the Sforza Castle.
In Florence Girolamo Savonarola is sentenced to death. Antonio Pollaiolo dies in Rome. Michelangelo agrees to sculpt the Pietà *for St. Peter's in Rome.*

1499
Leaves Milan and stays in Mantua with Isabella d'Este, making two drawings of her.
Milan is occupied by French troops. Luca Signorelli begins work on the frescoes in the Cathedral of Orvieto.

1500
Arrives in Venice, where he advises on military projects against the threat of a Turkish invasion.
Having moved back to Florence, receives the commission from the monks to create an altarpiece for the Monastery of Santissima Annunziata.
Raphael and Evangelista di Pian di Meleto receive a commission to paint the altarpiece dedicated to St. Nicholas of Tolentino.

1502
Enters the services of Cesare Borgia as an architect and military engineer.
Donato Bramante designs the courtyard of the Belvedere and the Tempietto of San Pietro in Montorio.

1503
Returns to Florence, where *gonfaloniere* Piero Soderini commissions him to paint the *Battle of Anghiari* and to design a project to deviate the course of the river Arno.
Starts working on the *Mona Lisa* (according to Vasari).

1504
Participates in the debate to decide the appropriate location of Michelangelo's *David* in Florence.
Raphael paints his Marriage of the Virgin. *Michelangelo finishes his* David.

1506
The ancient statue the Laocoön *is unearthed in Rome. Pope Julius II conquers Bologna.*

1508
Leaves Florence for Milan, having been summoned by the French governor, Charles d'Amboise.

1513
Moves from Milan to Rome, and is given an apartment in the Belvedere Palace by Giuliano de' Medici, brother of the new Pope, Leo X, where he stays for the next three years.
Pope Julius II dies and is succeeded by Giovanni de' Medici, as Leo X.

1516
Invited to work in France by King Francis I, who gives him lodgings in the manor house at Cloux.
After the death of Ferdinand the Catholic, King of Spain, Charles of Habsburg inherits the territories of Castile and Aragon, as well as Naples, Sicily, and Sardinia.

1519
23 April: Writes his will and gives it to his assistant Melzi.
2 May Dies in Amboise.
Following the death of Maximilian of Austria, Charles of Habsburg becomes Holy Roman Emperor, as Charles V. Pope Leo X commissions Michelangelo to design the New Sacristy for the church of San Lorenzo in Florence.
Raphael designs the villa on Monte Mario, known from then on as the Villa Madama.

Literature

In Leonardo da Vinci's own words:

The Notebooks of Leonardo da Vinci, ed. Irma A. Richter, Oxford 1998

Leonardo on Painting: An Anthology of Writings, ed. Martin Kemp and Margaret Walker, New Haven 1989

Contemporary text:

Giorgio Vasari, Lives of the Painters, Oxford 1998

Studies:

Kenneth Clark, Leonardo da Vinci: An Account of His Development as an Artist, London 1939 (rev. 1952)

Kurt R. Eissler, Leonardo da Vinci: Psychoanalytical Notes on the Enigma, New York 1961

A. E. Popham, The Drawings of Leonardo da Vinci, London 1964

Cecil Gould, Leonardo: The Artist and the Non-Artist, Boston 1975

A. Richard Turner, Inventing Leonardo, New York and London 1993

Serge Bramly, Leonardo: The Artist and the Man, London 1995

David Alan Brown, Leonardo da Vinci: Origins of a Genius, New Haven 1998

Claire Farago, Leonardo's Science and Technology, New York and London 1999

Pietro C. Marani, Leonardo de Vinci, New York 2000

Michael White, Leonardo: The First Scientist, New York 2001

Donald Sassoon, Mona Lisa: The Making of a Global Icon, New York 2002

Pietro C. Marani, Leonardo. Catalogo completo dei dipinti, 1989. English translation: Leonardo: The Complete Paintings, New York 2003

Frank Zöllner and Johannes Nathan, Leonardo da Vinci, 1452–1519: The Complete Paintings and Drawings, London and Cologne 2003

Martin Kemp, Leonardo da Vinci: The Marvellous Works of Nature and Man, Oxford 2004

Simona Cremante, Leonardo da Vinci: Artist, Scientist, Inventor, Florence and Milan 2005

Charles Nicholl, Leonardo da Vinci: The Flights of the Mind, London 2005

Agnese Antonini and Alessandro Guasti, Leonardo: l'opera pittorica completa, 2006. English translation: Leonardo: The Complete Works, New York 2007

Luke Syson and others, Leonardo da Vinci: Painter at the Court of Milan, London and New Haven 2011

Photo credits